PORTOBELLO
& DISTRICT

THROUGH TIME

Archie Foley &
Margaret Munro

AMBERLEY PUBLISHING

Acknowledgements

Many of the images in the book come from our personal collections but we have to thank the following persons and organisations for the loan of material: Janet Buchan; Dorothy Coutts; Gus Coutts; Craigmillar Community Arts; Duddingston Kirk; Norman Fisher; Tom Forsyth; Bryan Gourlay; Bob Jefferson; Arthur Jeffery; Dorothy Kelly; Alistair Kerr; Jim Lewis; Lothian Health Service Archive (photographs of Seafield Hospital); Joe Madden; Margeorie Mekie; William and Derek Morrison; Harriet Munro; Betty Norris; Les Solley (King's Manor Hotel); Portobello History Society; John Stewart; Myra Thomson; Willowbrae Bowling Club and Eric Wishart. Thank you also to those who allowed themselves to be photographed and to those who let us into their homes to take photographs from their windows.

First published 2010

Amberley Publishing Plc
Cirencester Road, Chalford,
Stroud, Gloucestershire, GL6 8PE

www.amberley-books.com

Copyright © Archie Foley & Margaret Munro, 2010

The right of Archie Foley & Margaret Munro to
be identified as the Authors of this work has been
asserted in accordance with the Copyrights, Designs
and Patents Act 1988.

ISBN 978 1 84868 805 6

British Library Cataloguing in Publication Data.

A catalogue record for this book is available from
the British Library.

Typeset in 9.5pt on 12pt Celeste.
Typesetting by Amberley Publishing.
Printed in the UK.

Introduction

Changes in the place where you live can be so subtle that it is often years before you realise that anything has changed or, they can be so dramatic that you can hardly remember what it looked like before. We hope to show examples of both in the following pages.

Portobello lies about five miles east of Edinburgh on the shore of the Firth of Forth and is often called "Edinburgh's seaside suburb" and its neighbours illustrated in this book have had close economic and social links with Portobello over many years. The loss of many industries, such as brick making, coal mining, brewing, pottery, bottle works, electricity generating and salt manufacture here means that people no longer live where they work, resulting in increased traffic and the creation of what some might describe as dormitory suburbs. Brownfield sites have been re-zoned for housing to accommodate the ever-increasing demand for homes in Edinburgh and smaller communities have been incorporated into the city. However, these communities are still keen to maintain their own identities and individuality and work hard to do so.

Much of Portobello is a conservation area, meaning changes are more closely controlled. The loss of industry and leisure here did allow some changes to take place, with industrial and leisure sites replaced by housing. Craigmillar, Portobello's near neighbour, has experienced some dramatic developments, with inter-war housing demolished to make way for modern homes. However, recent economic difficulties have meant that many areas lie desolate until more funding can be secured. There are empty grass covered spaces waiting to be restored to life. It is therefore vital to record these changes to ensure that they do not go un-noticed or unmarked.

Increased traffic has resulted in busy roads, with once quiet country lanes widened and surfaced to accommodate the cars, buses and lorries that now use them.

Trends in architecture change and examples of this can be seen here. The established buildings of Portobello, protected by their conservation designations, sit side by side with modern developments, not always universally loved. Many of the new houses in Craigmillar belong to housing associations, created to offer affordable, rented accommodation to residents, with other houses offered for sale, encouraging a move to home ownership.

Other changes are more subtle, with windows changed, chimneys taken down, extensions built or gardens paved over to provide parking, particularly where streets cannot cope with the increased number of parked cars. Churches have been converted into flats, rather than being demolished, with empty shops redeveloped as houses.

Street scenes have changed. Apart from the obvious increase in traffic, there are road markings to enforce regulations and traffic lights controlling movement. There is an abundance of street furniture, a term used to describe benches, cycle racks, litter bins, finger and sign posts and wheelie bins, which provide refuse disposal for the residents of tenements and recycling facilities for all. Trees and shrubs are now planted to provide greenery and pleasant surroundings. Many of these changes go un-noticed until comparisons are made with old photographs. There is little opportunity now to collect manure for your garden from the street and seldom will you find a policeman controlling traffic.

However, this is not to say that all modernisation is unwelcome. Many streets have been opened up and appear brighter; modern homes provide better facilities. Some may say that neighbourliness and caring for others in your community have been lost, particularly where widespread demolition has taken place, but determination to retain community spirit exists.

Comparing then and now is not always straightforward. Colour photographs make everything appear brighter and more colourful. Clothes are more colourful and less restrictive. A day at the beach now does not necessarily entail wearing your hat and coat, even on a hot sunny day! We hope this book highlights the changes in your neighbourhood and jogs your memory, encouraging you to share your memories with those around you.

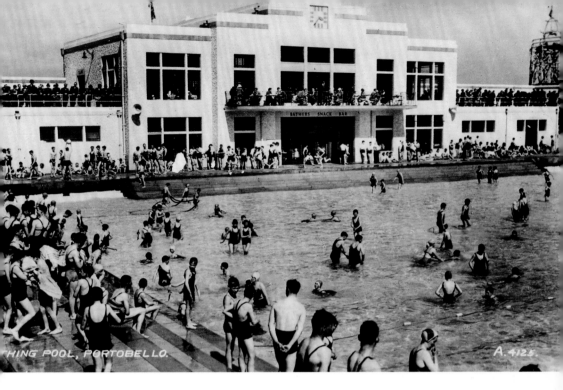

BATHERS SNACK BAR

...HING POOL, PORTOBELLO. A.4125.

Indoor Bowls

The art deco style function suite at the shallow end of the Open Air Pool featured in a book about distinguished Scottish architecture of the 1930s so the decision to demolish it did not meet with universal approval. Its eventual replacement by the structure housing the Portobello Indoor Bowls and Leisure Centre did little to mollify the critics.

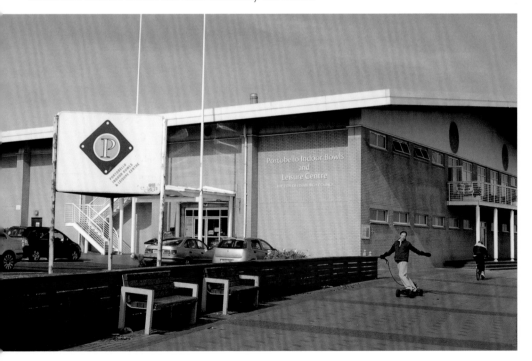

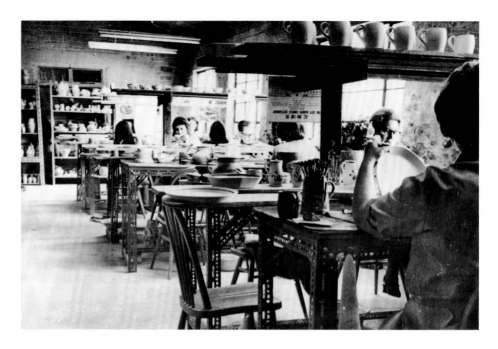

The Buchan Pottery

The workforce who hand decorated the stoneware produced by A. W. Buchan & Company Ltd was mainly, but, not exclusively, female. The pottery opened in Portobello in 1867 but moved to Crieff in 1972. These two early twentieth century bottle kilns are the only structures that remain and one is at present [summer 2010] being restored by the City of Edinburgh Council.

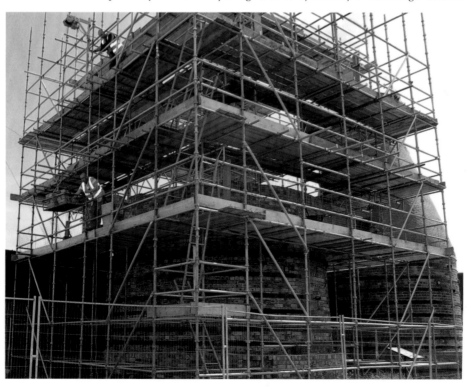

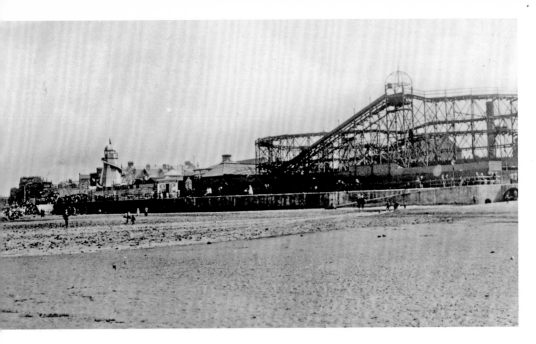

Fun for All

Portobello's Fun City was the second oldest fairground on a permanent site in Britain but was too small to survive changing holiday patterns. The modern Fun Park survives and provides amusements for visitors no matter the weather, as all the entertainment is inside a brightly lit arcade.

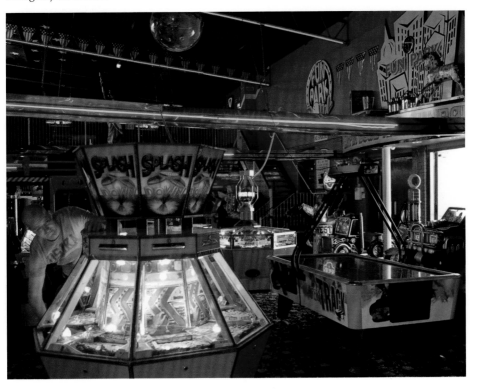

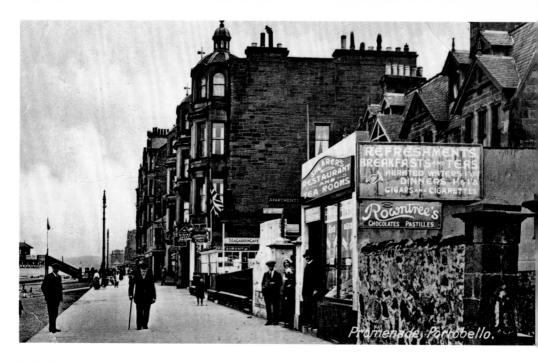

Bath Place

The removal of the shop, the two storey houses and later a rundown Ghost Train not only opened up long hidden sea views for the occupiers of the nineteenth-century cottages in Bath Place, but also treated pedestrians on the Promenade to striking views of Towerbank Primary School and the eighteenth-century Portobello Tower.

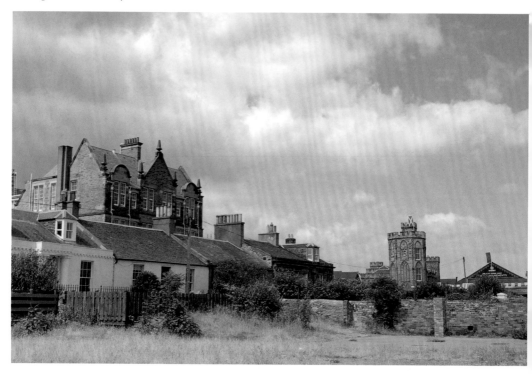

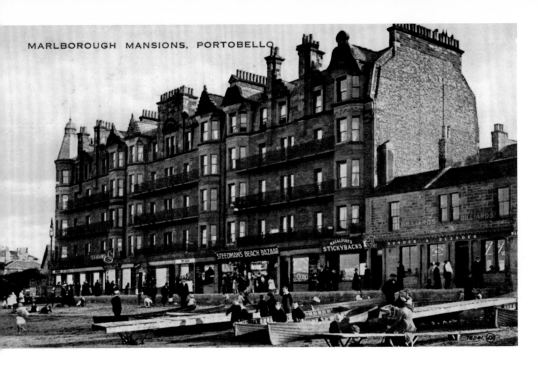

MARLBOROUGH MANSIONS, PORTOBELLO

Marlborough Mansions and the Foot of Bath Street

This has always been the busiest part of the beach. Marlborough Mansions, from the 1890s, was a distinctive example of Scottish Victorian tenement design and the decision to demolish it was challenged by many. The 2005 apartment block built on the corner site brings a flavour of Florida to Portobello and shows up well here against a blue sky. It is perhaps too early to say whether it will gain the same measure of public affection.

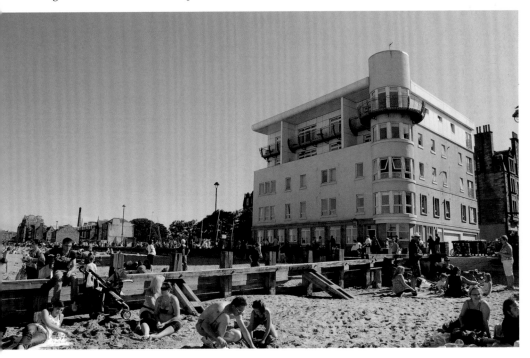

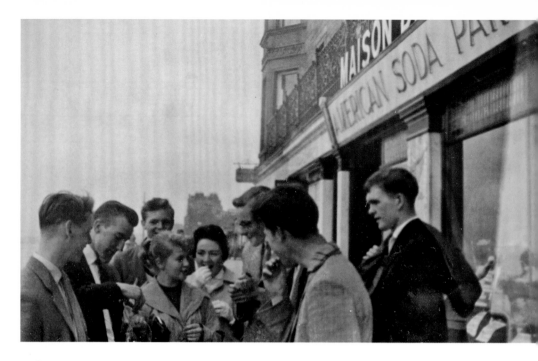

Maison Demarco

For teenagers such as these in the 1950s Maison Demarco's American Soda Parlour and Café was the place to hang out and be seen. It was the classiest establishment at the promenade level of Marlborough Mansions and even employed a piano player to entertain its patrons. The site once occupied by the tenement block is now the boatyard from which junior members of the Yachting and Kayaking Club are taking a yacht to the shore.

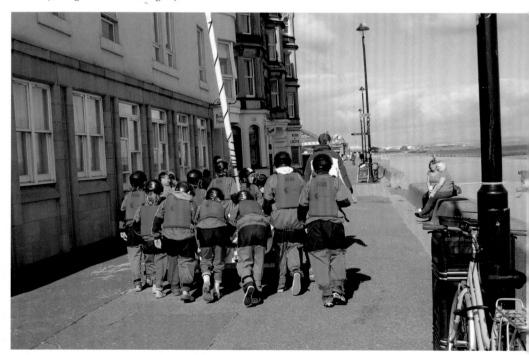

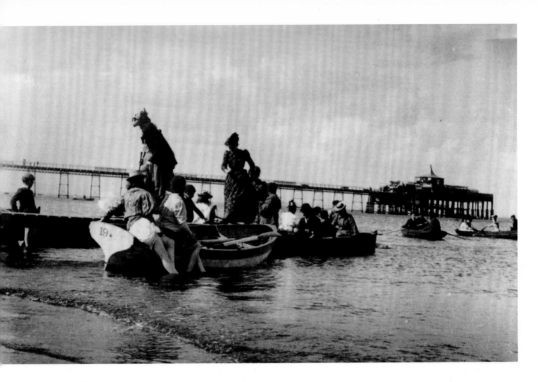

Dressing for the Occasion

Edwardian ladies made very few concessions with regard to dress no matter what activity they were engaged in, so getting into rowing boats obviously required some care. Modern water sports gear makes life easier and safer.

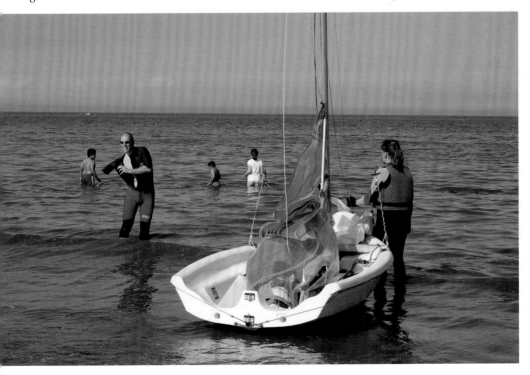

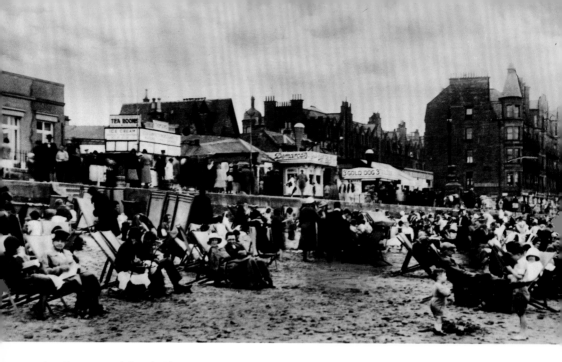

Ice Creams and Candy Floss

A lack of ice cream parlours, cafes and suchlike facilities along the promenade is often commented on by visitors to Portobello. More would be welcome but a return to anything like this 1930s picture is highly unlikely. On the other hand, there are those who appreciate the opening up of the Promenade's hinterland and the creation of grassy spaces for general use.

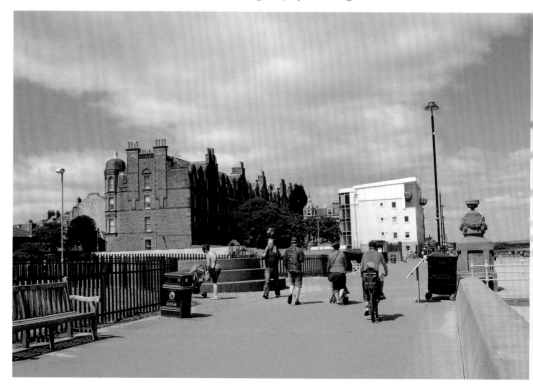

Seaside Entertainment

Portobello had its pierrots and concert parties from the beginning of its career as a holiday resort. In the 1930s large professional companies came for a summer season to a fully equipped temporary marquee theatre erected at the foot of Marlborough Street. Now, the same location is the venue for a wide variety of public entertainment organised and mounted by local community groups.

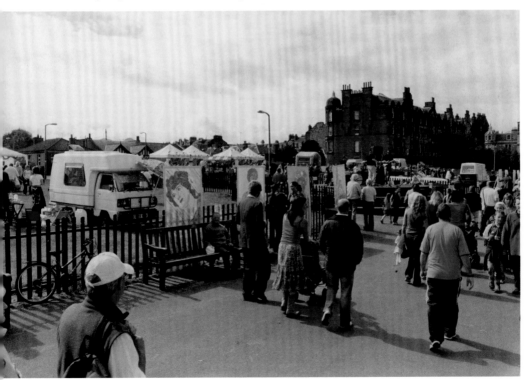

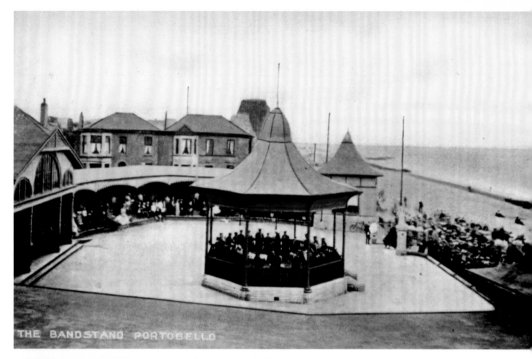

THE BANDSTAND PORTOBELLO

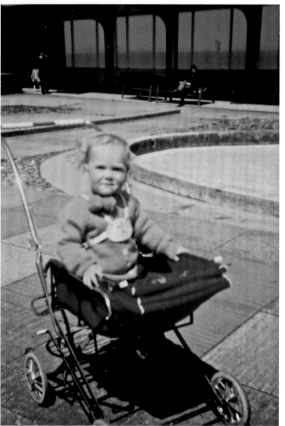

The Bandstand

There is a truly Edwardian flavour
here that would have been replicated
in seaside resorts all over the country.
An added attraction of the Portobello
bandstand was a ballroom, seen on
the left, and dances were organised
here for service personnel during
the Second World War. A children's
paddling pool with a grassy area
replaced the bandstand in 1960 but
there was no water in the pool when
Baby Denise visited.

Portobello Community Garden

The paddling pool was also used as a venue for performers in locally organised community music and arts festivals but it was allowed to deteriorate over many years until the site became a victim of vandalism and dereliction. However, a massive effort by individuals and local organisations raised sufficient funds and, working with the City of Edinburgh Council, created this community garden, opened in 2008.

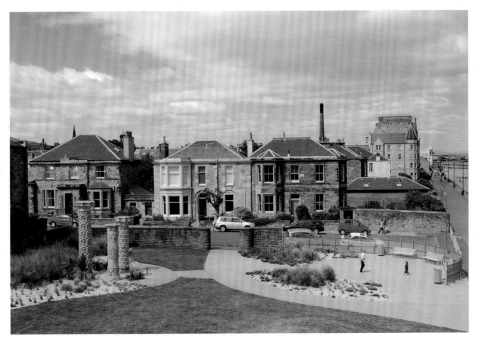

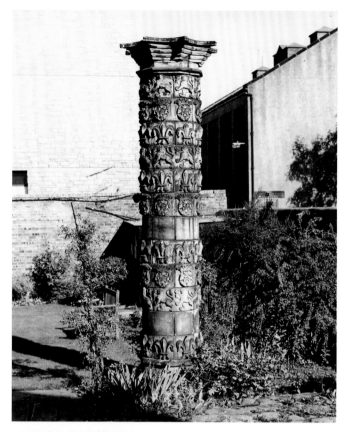

The Coade Stone Pillars
These pillars are the centrepieces of the community garden but are actually decorated chimney pots made in the early nineteenth century of artificial stone according to the recipe of Mrs Eleanor Coade of Lambeth, London. They stood for generations painted black in a garden off Portobello High Street, but were taken into the care of Edinburgh Council when the house became a nursing home. Community effort raised the funds to restore the pillars and have them re-erected in Portobello.

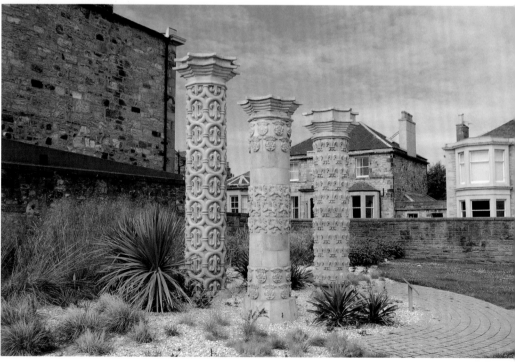

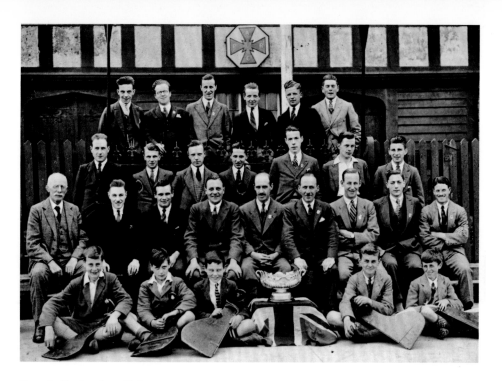

Portobello Rowing Clubs

Portobello Amateur Rowing Club members pose outside the wooden boathouse fronting the promenade in about 1925. The Eastern Amateur Rowing Club shared the same plot of land at the foot of Pittville Street and both were active and successful for many years. However, shortly after celebrating its centenary in 1985, Portobello Amateur Rowing Club was forced to sell the land to a developer and the by now dilapidated wooden structures were replaced by this block of flats.

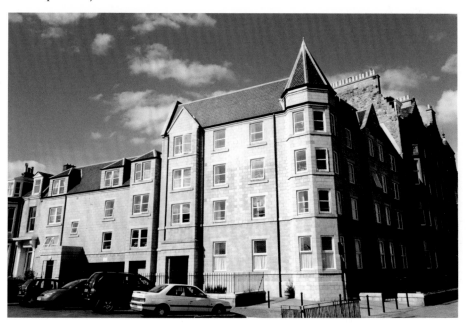

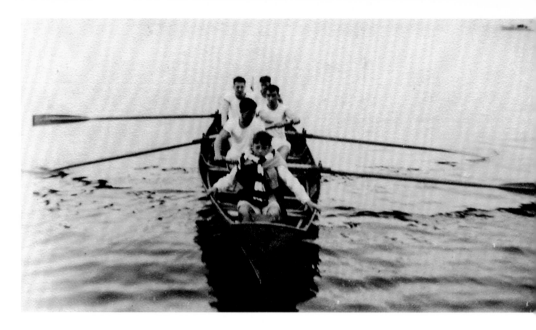

Jolly Boating Weather

In 1955 this crew from the Eastern Amateur Rowing Club won the Scottish Jolly Boat (Maiden) Championship at Portobello. Jolly Boats were the standard craft used in coastal water rowing and were larger and heavier than the skiff being rowed by the ladies in the Firth of Forth in summer 2010. They are members of the rowing section of the Portobello Yachting and Kayaking Club which in July 2010 successfully organised the first competitive regatta to be held in Portobello for forty years.

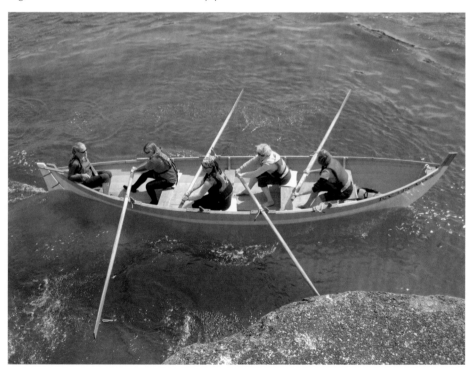

Fun on the Beach

There is a feeling of tranquillity in Edwardian family photographs that may have something to do with the long exposure times. However, despite appearances the three youngsters would probably have joined with gusto in the frantic activity of the local youngsters scrambling up the pyramids. The pyramids were constructed using sandbags as building blocks as a piece of public art that was enjoyed by many, not all of them youngsters.

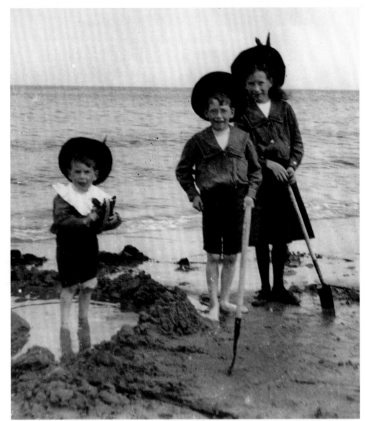

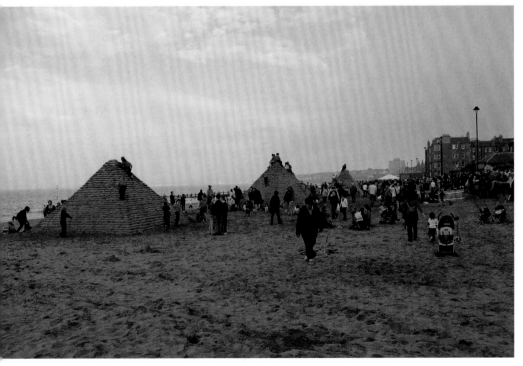

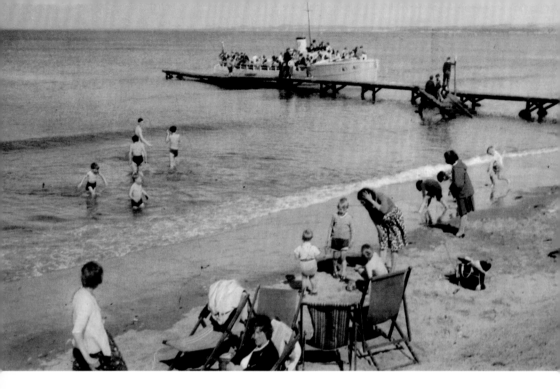

Anyone for the *Skylark*?
A leisurely sail around the bay in the sturdy little *Skylark* was very popular in the 1960s but more active ways of taking to the water are now popular. Water skis and jet skis have proven to be controversial as skiers have been accused of coming too far inshore.

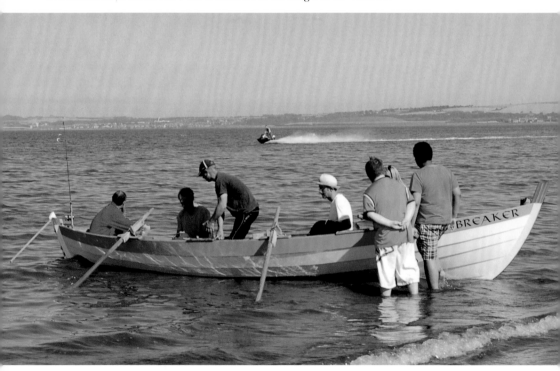

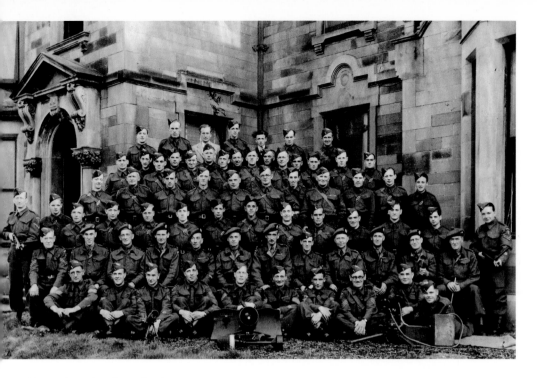

Home Guard to Beer Garden

Beachborough House at Joppa, one of the large mansions built on the Promenade in the nineteenth century, was the base for the local Home Guard unit in the Second World War. After the war, under various owners and with one or two changes of name, it was redeveloped as an hotel and café bar.

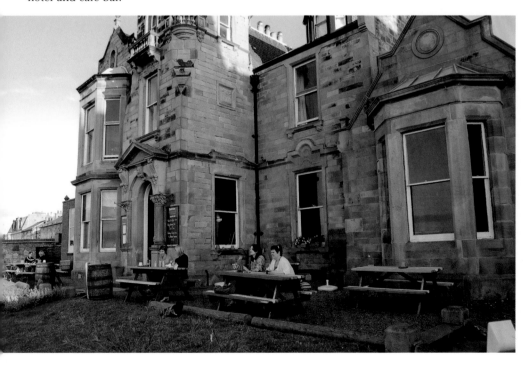

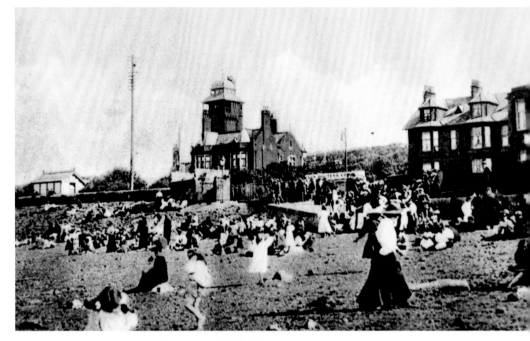

Joppa End

The eastern limit of the
Promenade and Portobello beach
is here at Joppa. The 1960s tower
block is built on the site of the
idiosyncratic mansion with an
observation tower and bears its
name, Coillesdene House. The
original Coillesdene House was
built using special high quality red
bricks brought from England and
became the property of the very
wealthy Mrs Marion Grieve at the
beginning of the twentieth century.
Mrs Grieve was a prominent figure
in local charitable organisations
and an active Suffragette
who took part in a number of
demonstrations in support of
votes for women. The suffragette
movement suspended activities
during the First World War and
Mrs Grieve channelled her energies
into raising money to provide
comforts for Scottish troops on the
Western Front. She hosted garden
parties and also invited soldiers to
musical evenings in the house. In
1954 her Trustees sold the property
to Edinburgh Corporation.

Full Circle

The foundations for the extension to Portobello Power Station were dug deep into the clay strata. The neighbouring houses were demolished to make way for the landmark building, which itself was demolished in 1977/78. A modern housing estate, with trees and shrubs, was then built on the site, returning it to its original function.

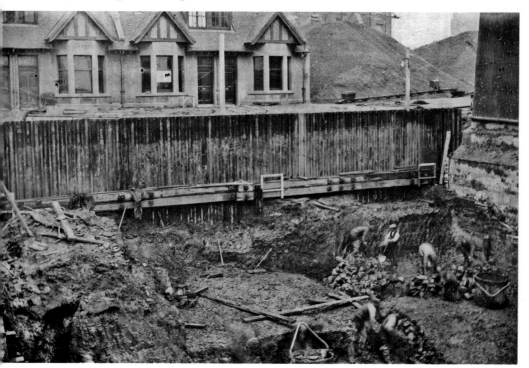

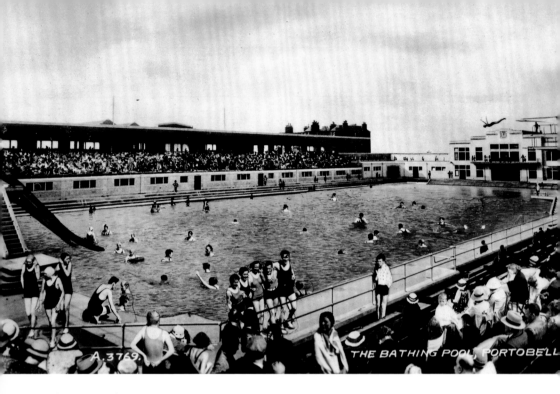

A.3769. THE BATHING POOL, PORTOBELL[O]

Leisure Pursuits

Portobello Open Air Pool provided bracing facilities for swimmers and divers, but others came only to pose in their swimwear before an admiring audience. For economic reasons the pool closed in 1978 and was demolished in 1988. These five-a-side pitches now provide an alternative form of exercise, although in a more mundane setting.

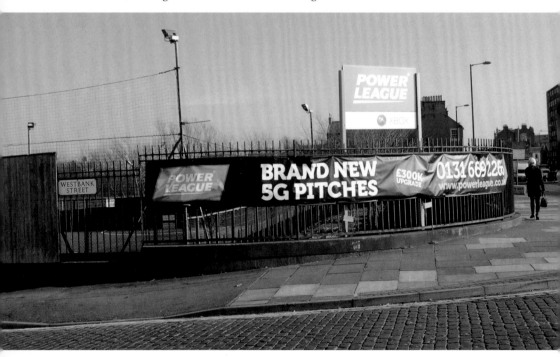

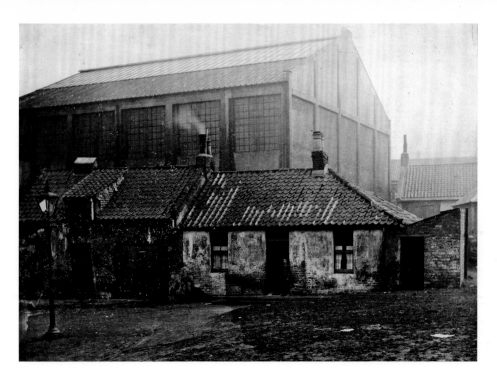

Scene Change

Unlike most places, industry was situated in the west end of Portobello. The poor living conditions of many of the workers are vividly illustrated in the original view of Rosebank Square. Behind the houses, and across the Figgate Burn, looms the paper mill, which closed and was demolished some years ago. Our photograph was taken from its former site in Bridge Street which is the only public car park in Portobello.

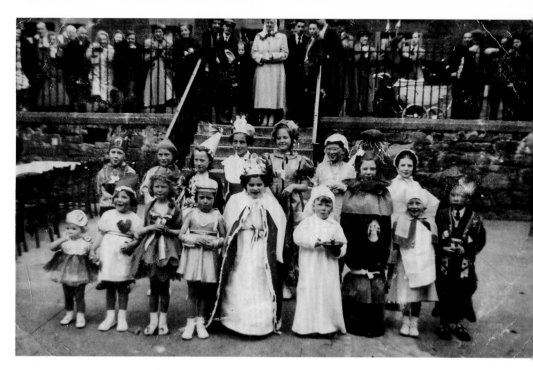

New for Old
Many families lived in the tenements of Pipe Street, which were typical of their time. After their demolition, new housing was built, and this colourful garden is located in a quiet courtyard almost on the same spot as the earlier scene.

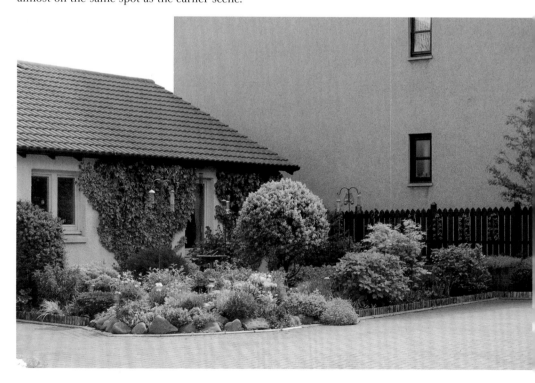

More Pipe Street

This gas depot in Pipe Street stored and distributed local supplies. After its demolition housing was built on the site and new residents often complained of a smell of gas without being aware of the site's previous use. This new council development won awards for its design and provided modern facilities unavailable to the former residents. Most of the homes are now privately owned, bought by tenants taking advantage of the 'right to buy' legislation.

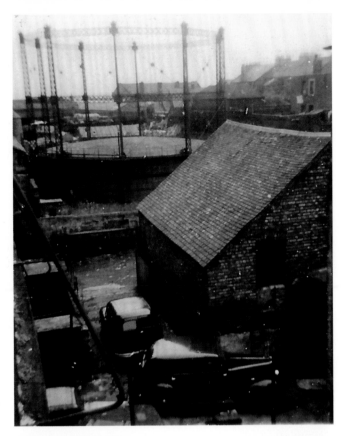

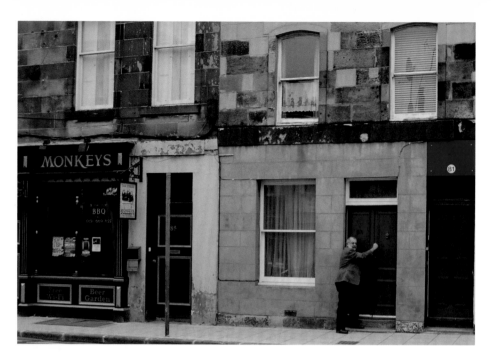

Revisiting the Past

On a holiday to Edinburgh from Australia, Norman Fisher revisited the site of his grandfather's shop at 83 Portobello High Street. He was surprised to find that it had been converted into a flat and was no longer the hive of activity it had been in 1934. Norman's father, Jack, seen here as a young man, became a well-known photographer in Portobello, much in demand for weddings.

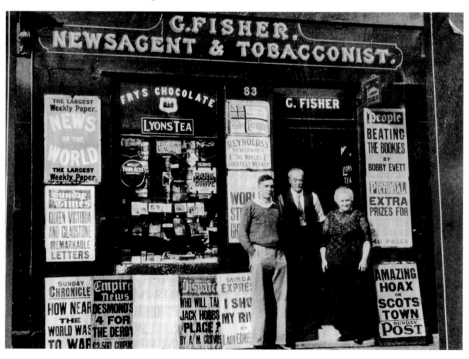

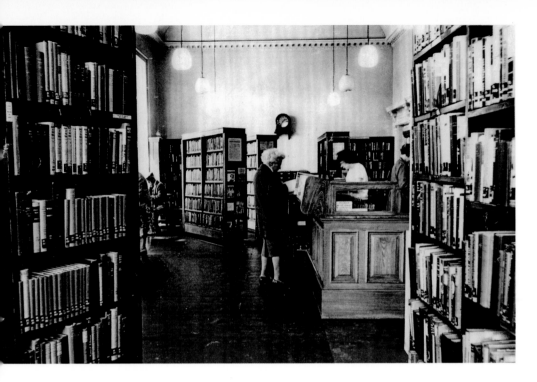

Into the Modern Age

Portobello Library, in the Police Station building, was a restful place to visit and borrow a book in the 1950s. A new library in Rosefield Avenue was opened in 1963 and was refurbished in 2010. It is now a modern hi-tech facility where computer games can be played and DVDs and CDs borrowed. The library is now open on Saturdays and Sundays to allow everyone access to the updated facilities.

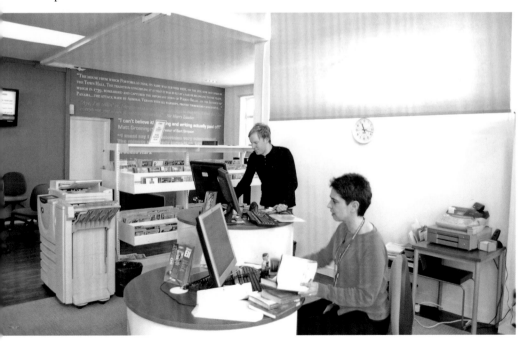

Café Culture

In the sunshine, modern Portobello dons a Parisian café culture look unimaginable to this family perhaps waiting for father to come out of the Railway Inn. The open, clean lines of the refurbished street, with new paving and cycle racks, contrast with the dark, narrow confines of the original scene.

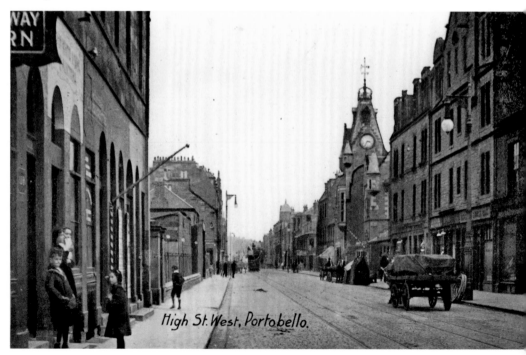

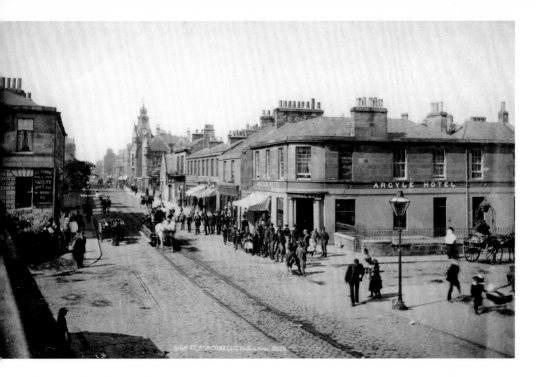

Photographers' Favourite

Horse-drawn trams stopped running to Portobello in 1902 and in the 100 plus years separating these two photographs this junction became the most photographed location in Portobello. It is the town's busy heart. The High Street brings traffic and people from east and west and Brighton Place from the south. The most popular route to the beach is down Bath Street, seen on the right.

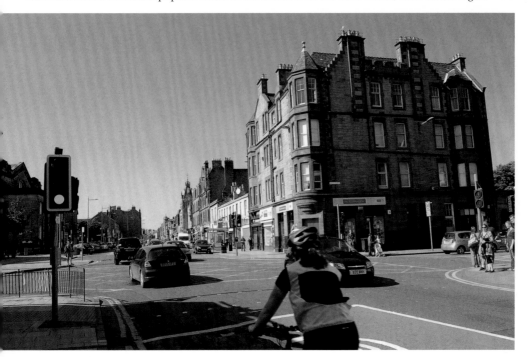

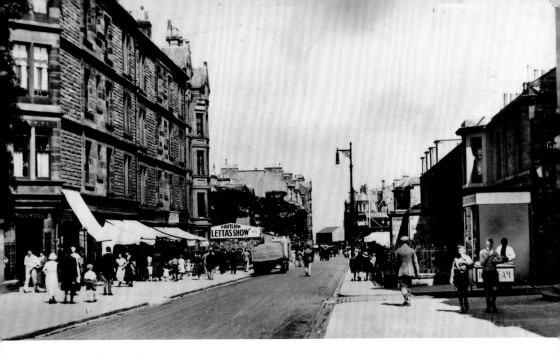

Down to the Beach

Bath Street today does not provide the same number of kiosks, shops and cafés as it did in the 1930s and there are no more live shows. The art deco style George picture house that replaced Letta's concert party pavilion is now a bingo hall.

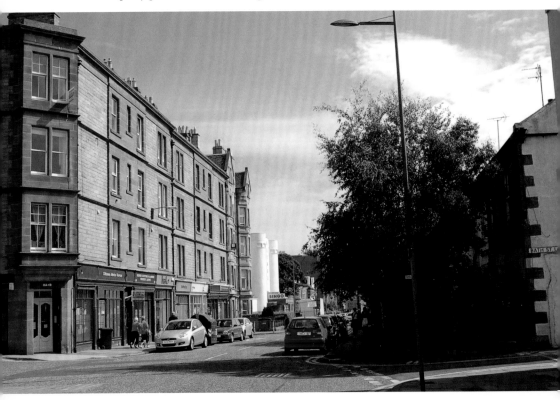

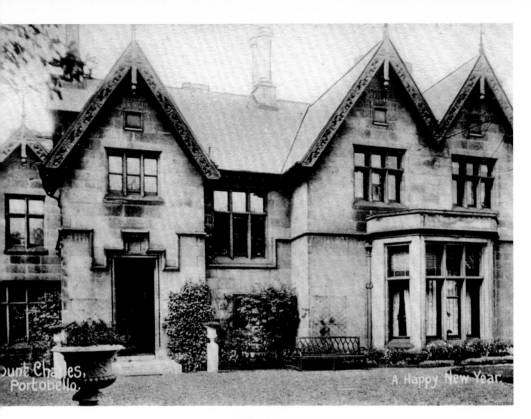

Mount Charles, Portobello. A Happy New Year.

Mount Charles

Mount Charles was a magnificent villa built in the late eighteenth century in what later became Bath Street. In the early 1900s Dr. Charles Frederick Knight owned it and converted it into a medical college for training young doctors. This was not a financial success and much of the ground was sold for development as housing and shops. Further financial problems led to the house being sold to the Roman Catholic Diocese of St. Andrews and Edinburgh in 1926. Mount Charles, known as the Guild House, served as the hall for St. John's Roman Catholic Church, where Boy Scouts met and social events were held. By 1966, it was deemed unsuitable and was sold to Portobello Cooperative Society Limited. This eventually merged with the Scottish Midland Cooperative Society Limited (Scotmid). The supermarket opened in the 1980s and has served the local community since.

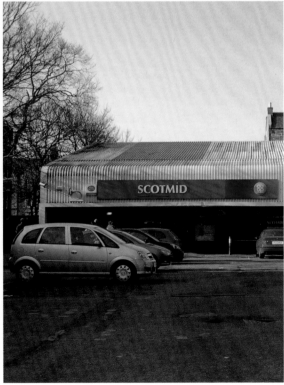

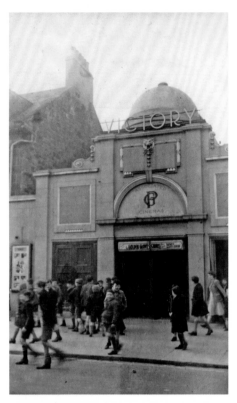

The Victory

There were two picture houses in Bath Street after the Second World War and the Victory was definitely the poor relation of the larger and more luxurious George nearer the top of the street. Fleapit was just one of the derogatory nicknames it gathered. The building had a variety of uses after closure in May 1956 but nature has now definitely taken over the site.

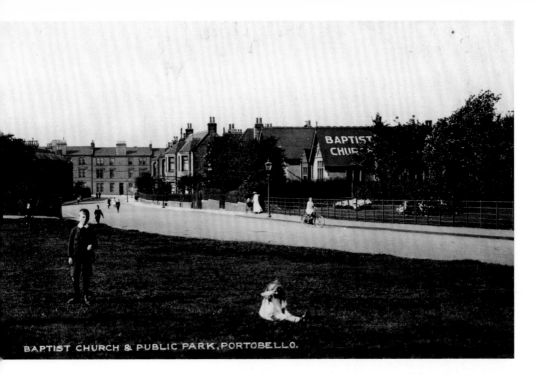

BAPTIST CHURCH & PUBLIC PARK, PORTOBELLO.

Baptist Church

The Baptist Church had a number of homes in Portobello, including the large house in Stanley Street near the golf course, before settling in at 185 High Street, which had housed Portobello Municipal Chambers between 1863 and 1877. It was a cinema before being bought by the church who share the building with a public house.

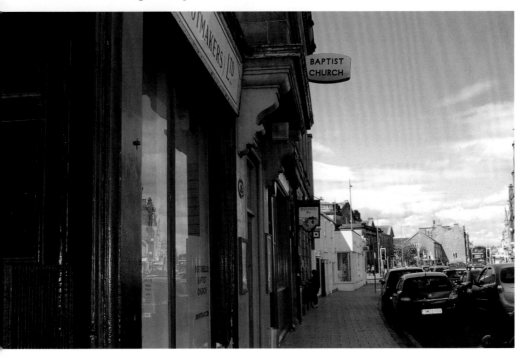

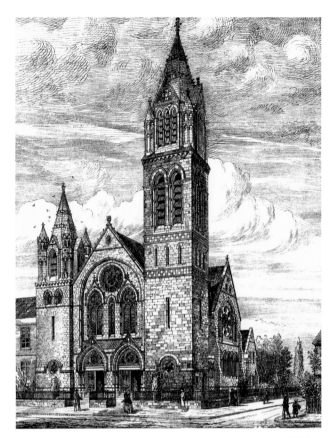

Mixed Generations
The fine architecture of
Windsor Place Church is
illustrated in this design sketch.
Thankfully, this was respected
when the church was converted
into retirement flats. Part of the
ground floor houses a children's
nursery so the building now
caters for two generations of
Portobello residents.

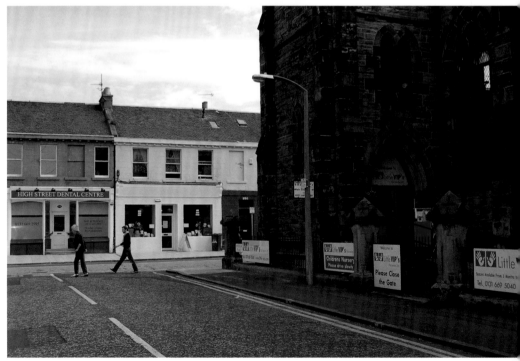

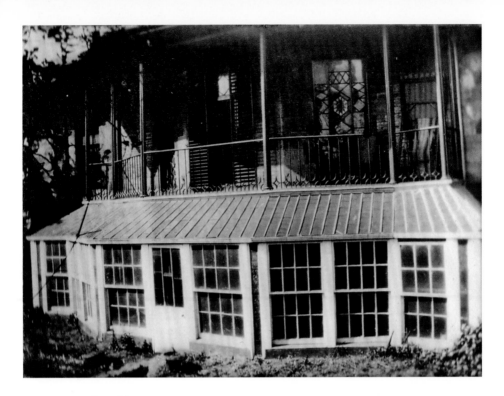

New Homes for Old

Mount Lodge mansion and estate were created in the early nineteenth century for a retired army officer, which may explain the colonial style conservatory. The house was demolished in 1936 after the LNER sold the estate to Edinburgh Corporation. A new housing development was built on the land. The refurbished play park was opened by the Duke of Edinburgh in 1971 aided by pupils from Towerbank and St. John's primary schools.

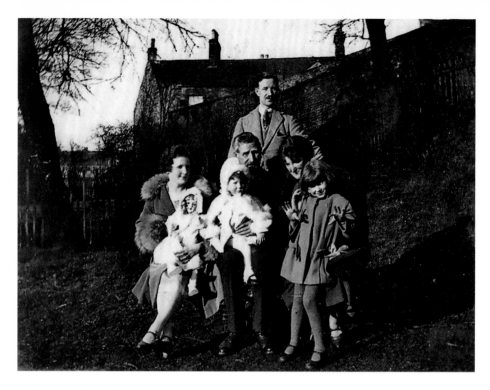

A Glimpse of Argyle House

Bert Cavaye and his family are in the grounds of Mount Lodge, with the roof of Argyle House in Hope Lane showing behind them. Where they are sitting is now part of the backgreens in Mount Lodge Place from where the building can still be seen. Velux windows suggest an attic conversion.

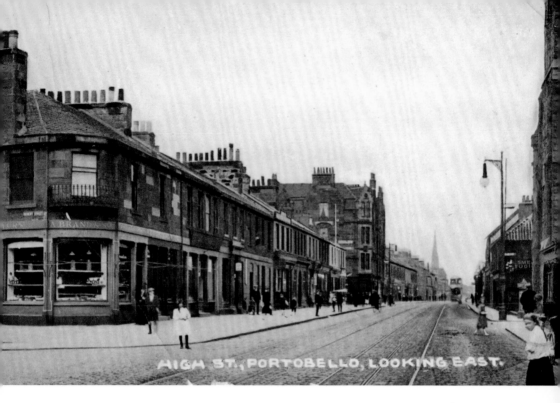

HIGH ST., PORTOBELLO, LOOKING EAST.

A Brighter Future

Viewed from both east and west, this fine stretch of shops still remains. Colourful advertising now brightens the street, with this popular hardware shop celebrating fifty years of business. The tramlines have been removed and the road has been resurfaced using a variety of colours and textures.

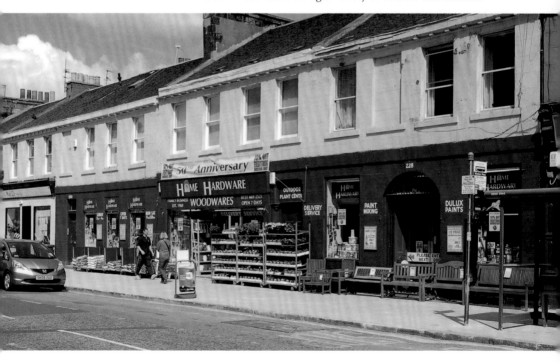

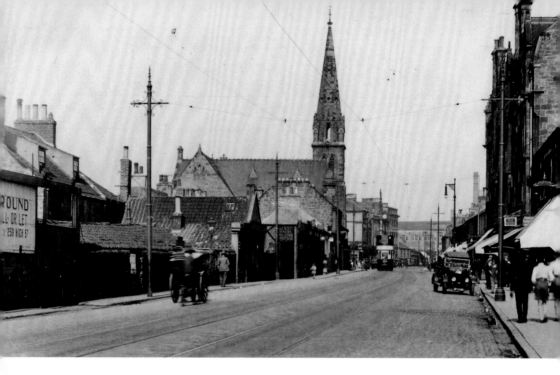

High Street looking West

It was easier for photographers back then, but it is no longer prudent to attempt to take photographs from the middle of the road. As there have been no great changes on the north side of the street, we took our shot from there to record those on the other side. Portobello Health Centre and welcome greenery have replaced the jumble of buildings and a sign for an Italian takeaway is on the gable of what was the Bluebell Inn.

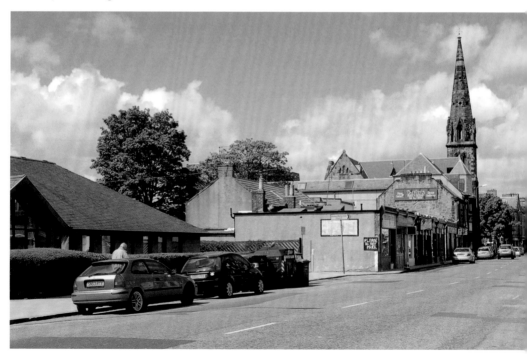

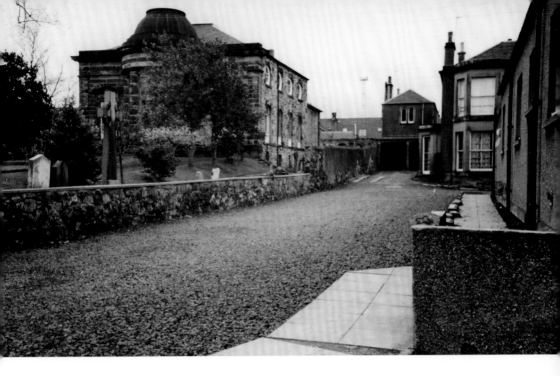

St Mark's Church

The apartment block with its well tended garden was built on ground where St Mark's Episcopal Church Hall and a large house known to church members as The Priory once stood. In fact, the house was never a priory and allegedly was named thus by a previous owner who won a large sum of money betting on a racehorse called The Priory.

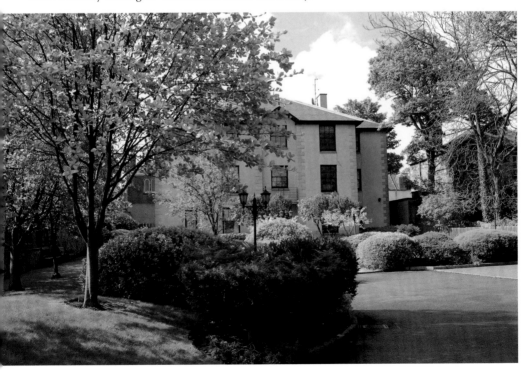

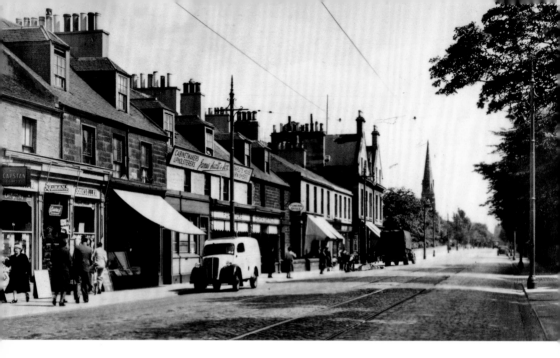

Community Care

James Scott's business provided a wide range of services for the Portobello community, from building trades and furniture sales to funeral services. Nowadays, dental care is provided on these premises. The busy newsagent's and the butcher shop next door remain, although there now appear to be more cars and fewer people on the street!

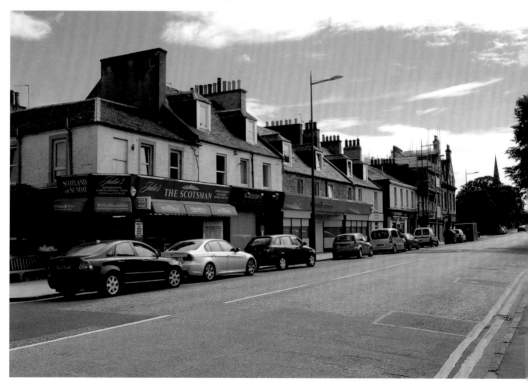

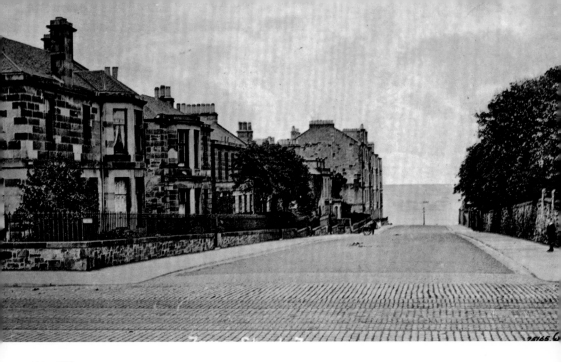

War Effort

The railings round the gardens in James Street were removed during the Second World War and only some have been replaced. Modern flats can now be seen behind the original wall on the right after the removal of some trees. There may be no cars in the original scene, but a nice heap of horse manure lies in the street awaiting collection for someone's garden!

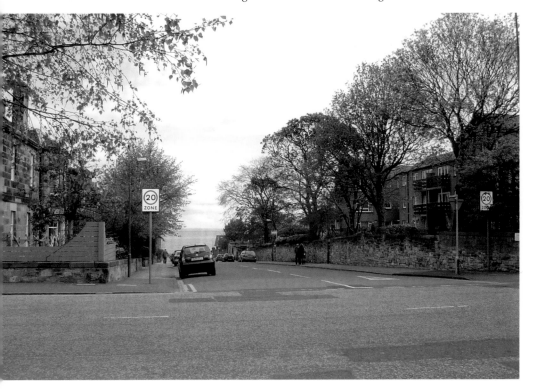

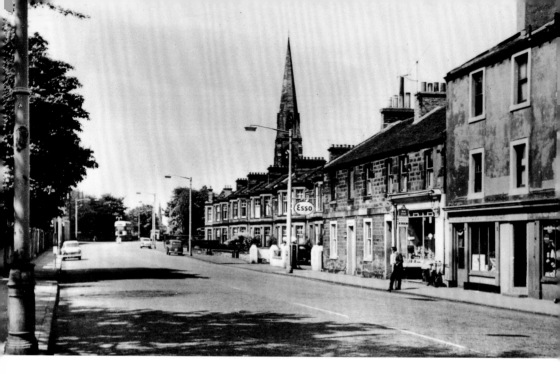

West Joppa

In both photographs the steeple of St Philip's Church is the focal point looking west along Joppa Road. Capturing the steeple against the evening sky meant including all those parked cars and two large refuse bins. However, increasing numbers of cars and a proliferation of street furniture are aspects of change over time that often cannot be avoided.

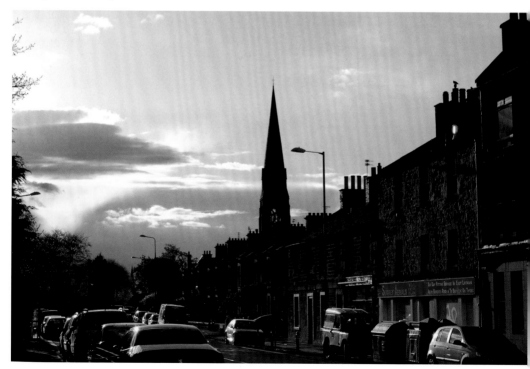

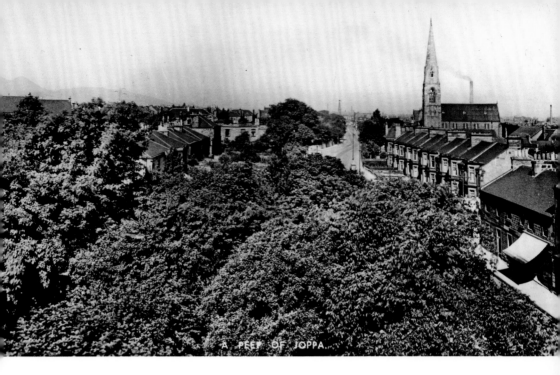

Leafy Suburb

We took our picture from almost the same vantage point as that used by the picture postcard photographer. From personal experience we know that Joppa has fewer trees than shown on the postcard, but is still a leafy suburb, so to see the gardens below the canopy our photograph was taken in the late spring.

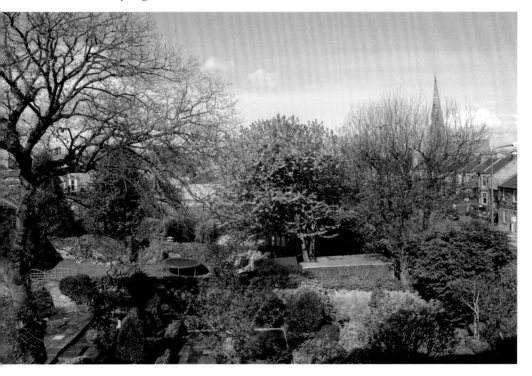

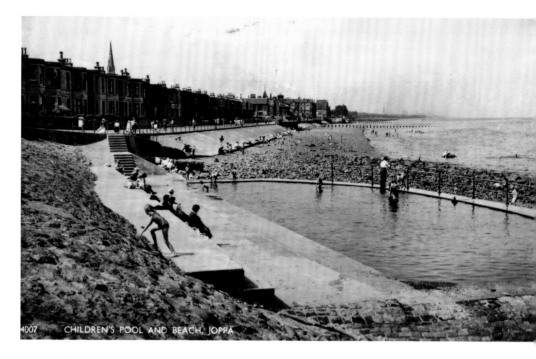

The Beach and Rocks

At Joppa the sand runs out and is replaced by rocks. The paddling pool was filled daily by the incoming tide. That being the case the water often contained crabs and other marine creatures to the delight, or distress, of the children paddling with bare feet. The pool and the rocks around it gradually became silted over until they disappeared altogether. A rather well designed sewage pumping station with an adjacent open area, or plaza, was built there.

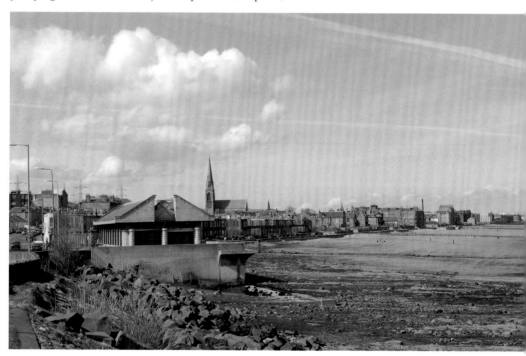

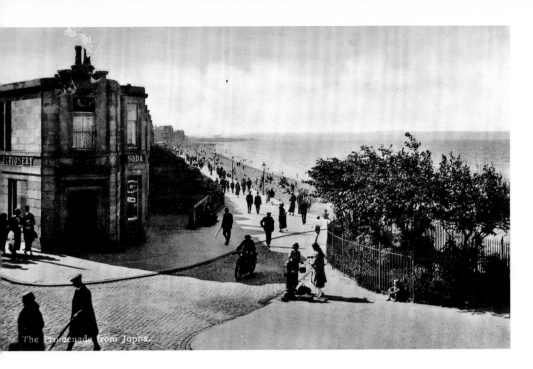

The Promenade from Joppa.

The Promenade from Joppa

For many years the front gardens, and sometimes the front rooms, of the houses would be flooded by waves crashing over the sea wall. Following work on the beach and coastal defences in the 1970s, this is now only a problem in extreme weather conditions such as occurred in spring 2010. The plaza is a very pleasant spot from which to watch activity on the beach and perhaps eat a dish from the Chinese takeaway that has replaced the café.

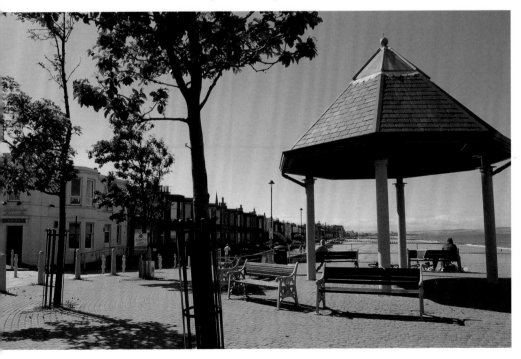

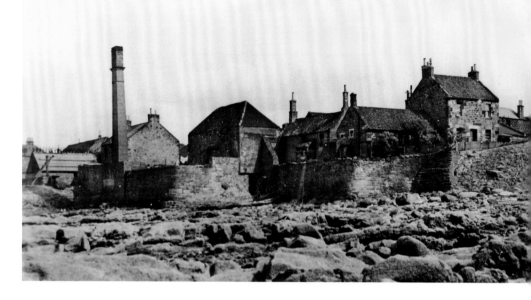

Joppa Rocks

Generations of young people have scrambled over the rocks from the end of the Promenade to the Salt Pans searching for creatures left behind by the tide. However, the outcrops also attract geologists and Joppa Shore has been designated a Regionally Important Geological Site (RIGS) because of its distinctive rock formations. One of the last vestiges of the salt works was destroyed during the great storm of April 2010 when huge waves swept away part of the old perimeter wall.

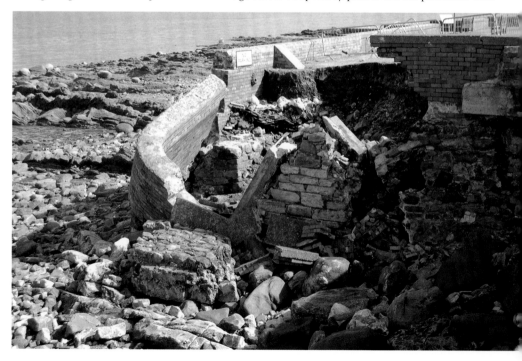

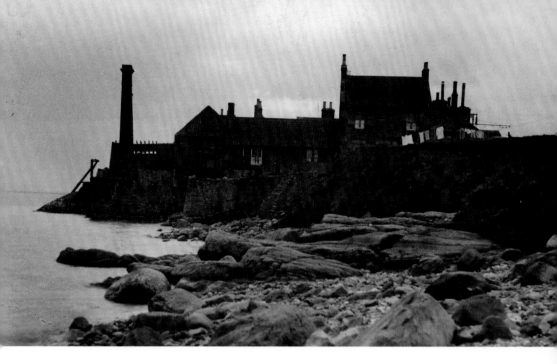

The Salt Pans

Production by evaporation of sea water began in the early seventeenth century and this settlement of salt workers and miners is the earliest in the area. Production later shifted to refining rock salt and ended in the 1950s. The works and all but two of the houses were demolished in the 1960s to provide a grassy open space. The white painted Rock Cottage is reputedly about 400 years old but its neighbour, now an hotel, dates from the nineteenth century.

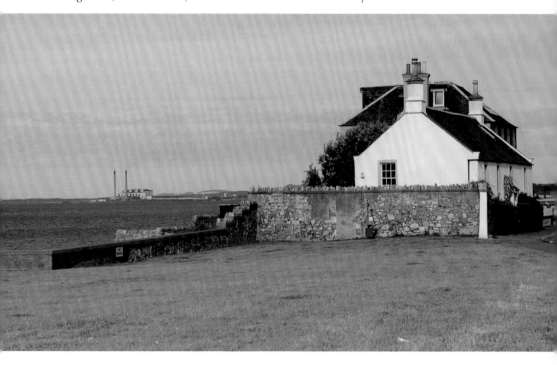

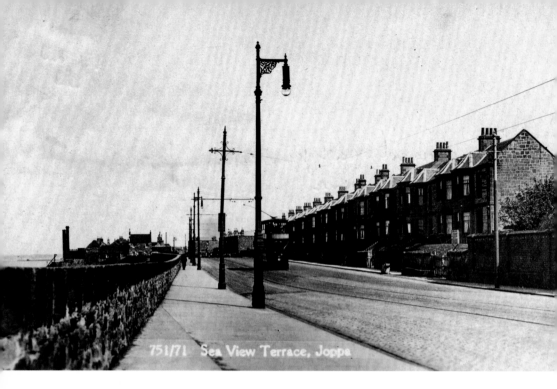

751/71 Sea View Terrace, Joppa

The Road to Musselburgh

Seaview Terrace is part of the road that connected Edinburgh with Musselburgh by tramcar and for a short time the route went on to Prestonpans. By taking a photograph across the bay over what's left of the saltpans, we see the post-war houses on Seaview Terrace and with the aid of the evening sun some houses in Musselburgh and the countryside beyond.

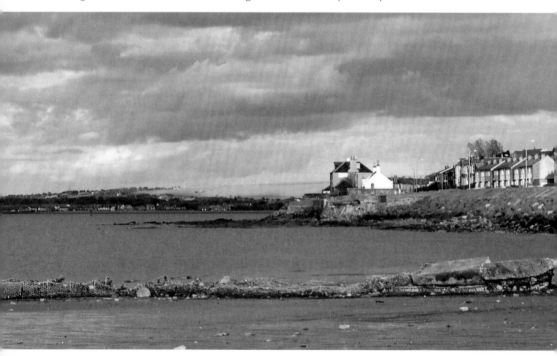

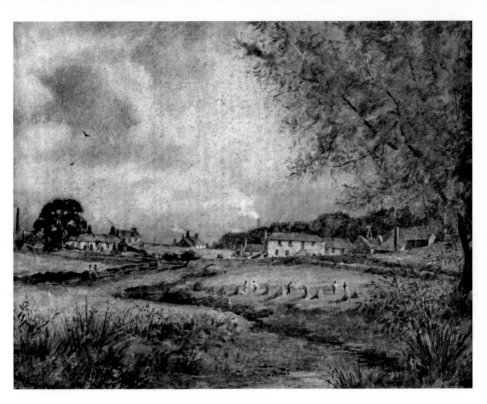

Rural Idyll

Brunstane Mill, depicted here by William Woolard, was situated right on the eastern boundary of Portobello. Some of the workers' cottages were still standing, albeit in a ruinous condition, as recently as the 1980s. The area has been landscaped and, although a number of houses have been built, there are still pleasant walks to be found.

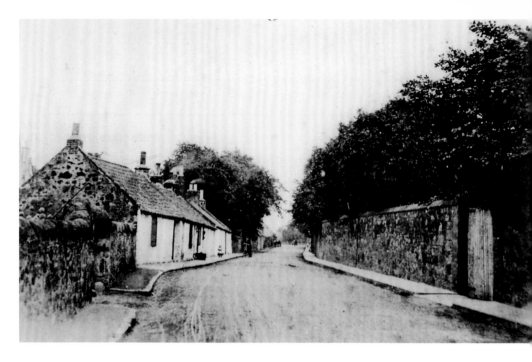

Easter Duddingston and Milton Road

In the early twentieth century Milton Road, seen here running through the remnants of Easter Duddingston village, had the character of a rural road. After the First World War the increase in motor traffic led to it being widened to become part of the then A1 Trunk Road between Edinburgh and London. All the space for widening was found on the south side as witnessed by the survival of the boundary wall of Queen's Bay Lodge.

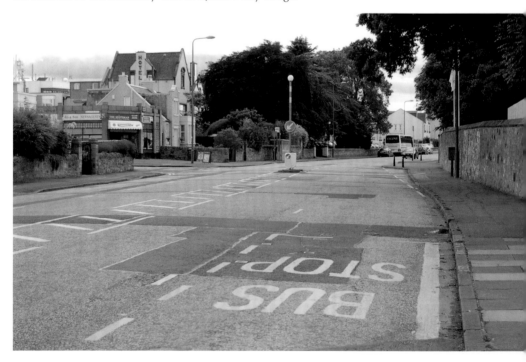

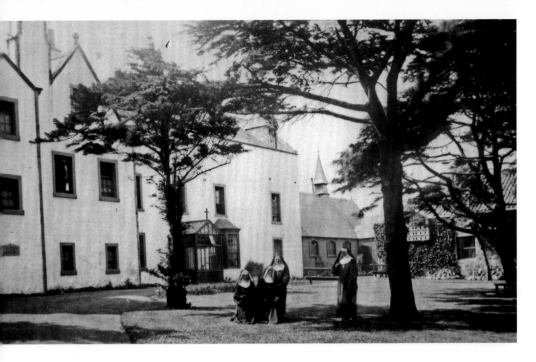

Care Home to Hotel

For seventy years nuns from the Order of St Andrew ran a home for the care and protection of vulnerable young women here on Milton Road East. It included a successful laundry business that contributed to running costs, but in 1955 was forced to close partly due to a drop in the number of girls being referred. The property was sold and became an hotel and, though much enlarged, retains part of the original building and trees from the garden.

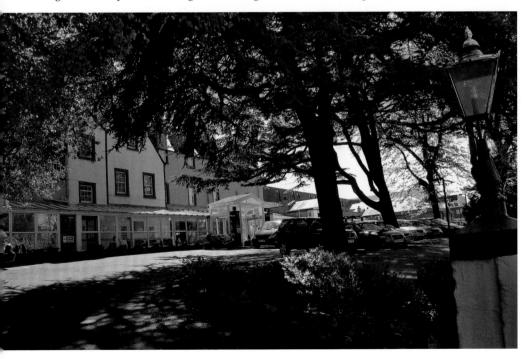

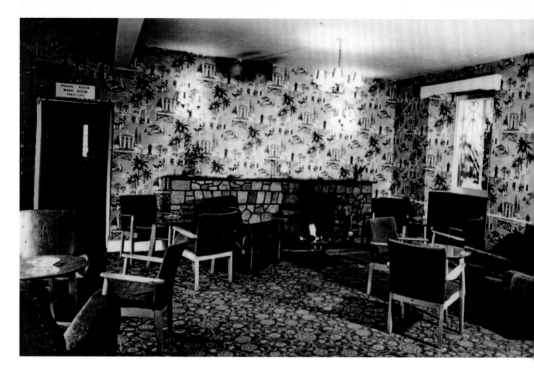

Interior Décor

Both authors remember when the wall and floor coverings of the hotel's public rooms were in that frantically busy style. Perhaps it is unfair to judge from a black and white photograph but the smoother lines and colour scheme of today's reception area are much more restful.

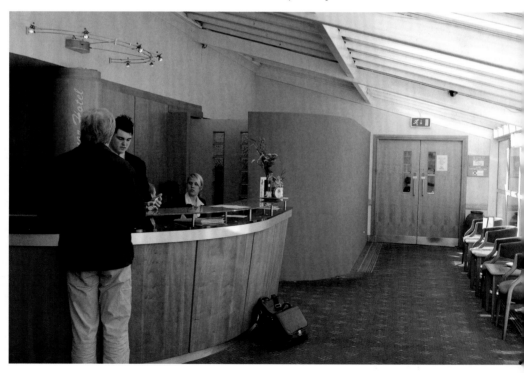

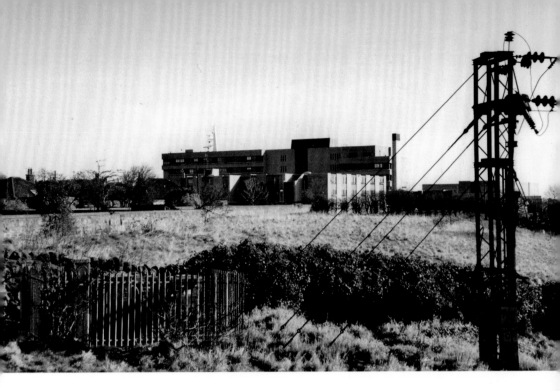

Jewel and Esk College
The photographs illustrate how house building has altered the landscape in recent years. Now Jewel and Esk College is barely visible from the same viewpoint by the railway line even though it has expanded greatly.

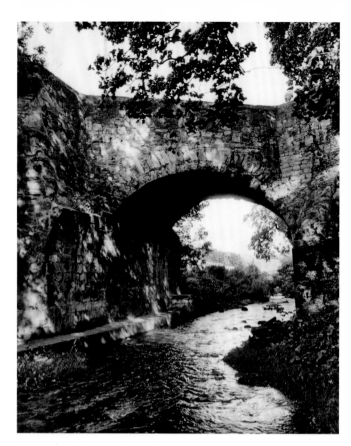

Roman Bridge
The Roman Bridge crosses high above the Brunstane Burn and once provided access to the countryside. This is no longer possible as the fields are now covered by housing. A section of an old wall still remains.

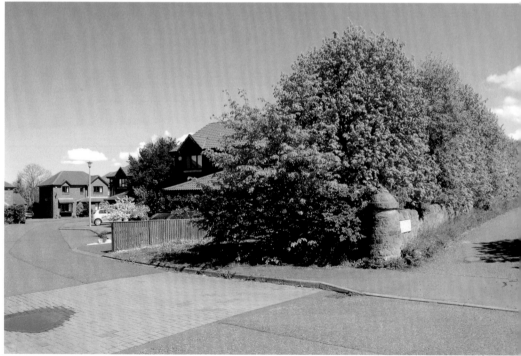

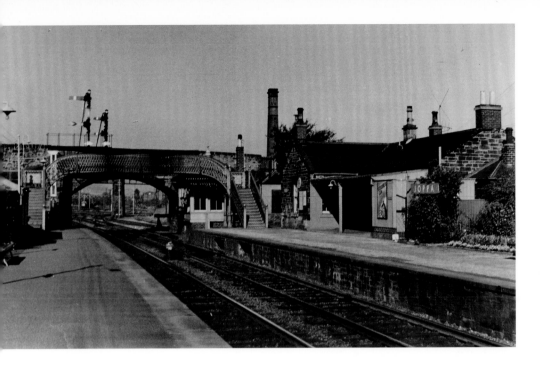

New for Old

When Joppa Station closed in 1964, the fast link to Edinburgh was greatly missed. However, this is now provided by the train service from nearby Brunstane Station, opened in 2002. This is proving very popular with commuters and the general public as it allows them to avoid traffic congestion in the city.

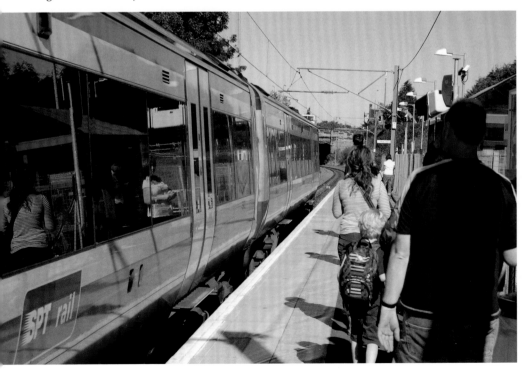

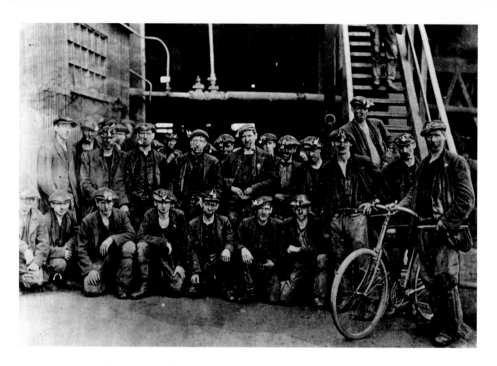

Newcraighall Colliery – The Klondyke

In 1897 the Niddrie and Benhar Coal Company began deep level mining at Newcraighall. The announcement that there were reserves that would last 300 years caused a jubilant workforce to nickname the colliery The Klondyke. Unfortunately, this forecast proved wildly optimistic as the mine was closed in 1968 on the grounds that extracting the coal had become too difficult and expensive. Its former site is now a very large retail park.

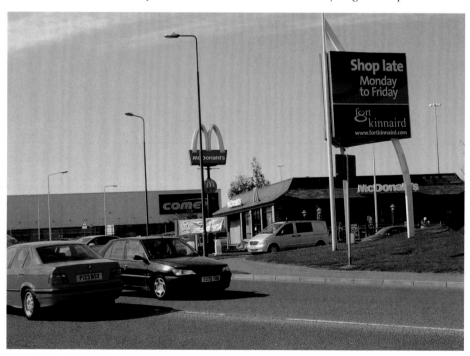

Death Sentence and Reprieve

In July 1971 Edinburgh Corporation recommended demolition of Newcraighall because the houses were declared to be unfit to live in and issued quit notices to the occupants. Councillor David Brown was one of the leaders of a vigorous and ultimately successful campaign to have the village redeveloped and so save the community. In 1972 Edinburgh Corporation agreed to rebuild the village and the sculpture on the village green celebrates the history and community spirit of the village.

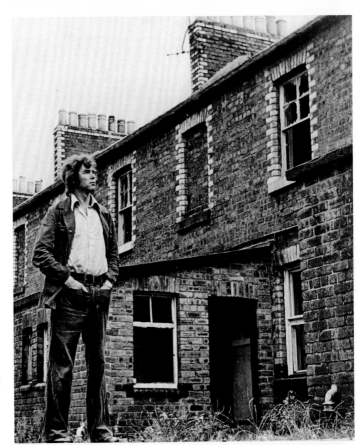

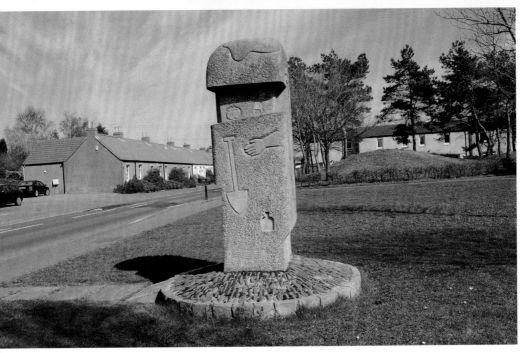

One Last Look
Robert "Bobby" Morrison, on
a visit to his house in North
Square before the area is
demolished, is looking over
towards the village school.
Today, the school is still there
but is surrounded by new
houses with all mod cons.
The ornamental fountain was
erected in 1907, in another part
of the village, in memory of
Dr Andrew Balfour who was a
well respected GP.

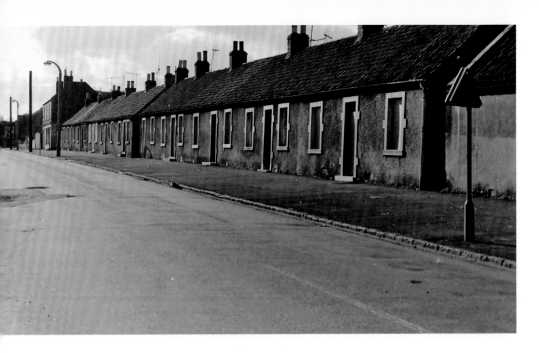

Whitehill Street

This is the main street through Newcraighall and the miners' cottages that run down one side were not demolished because they had been protected by a listing order. Instead, they were sold on the open market with refurbishment subject to preservation of their traditional character, with these very pleasing results. The village shop at the end of the row is still in business, which is also very pleasing.

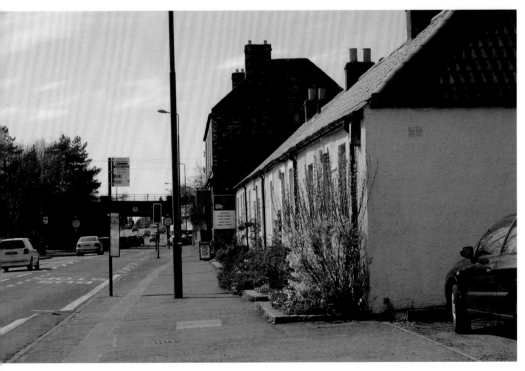

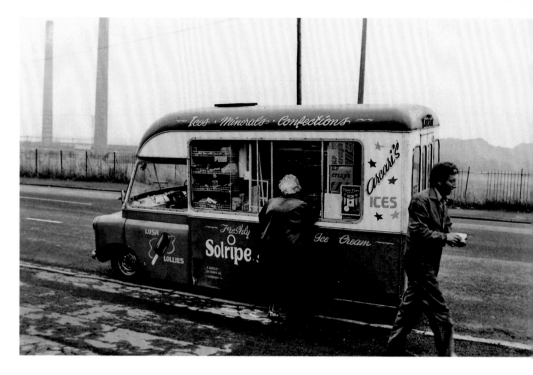

Ice Cream Van at the Brickies

The brickworks at Niddrie were a major employer in the area and their bricks served the needs of the local coal industry and the wider community. The site is now part of a retail shopping park. The ice cream van would have been parked at these well kept, modernised cottages which are built with local bricks.

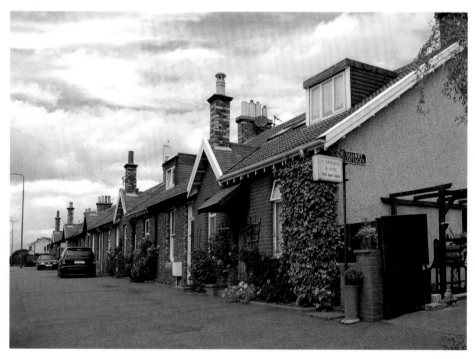

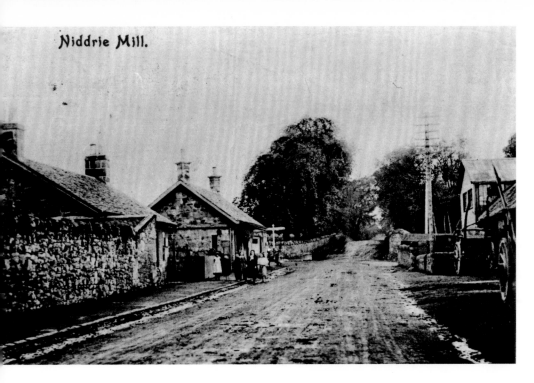

Niddrie Mill.

Niddrie Mill

In Edwardian times and for some while after, Niddrie Mill was a rural community with an unmade road leading to the crossroads at The Wisp. Now the junction is controlled by traffic lights because of the volume of traffic, although some fields still remain once you are through the lights and on to The Wisp.

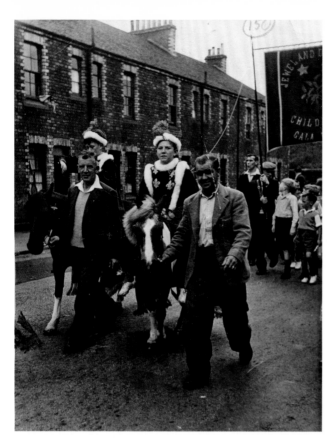

The Jewel
The annual Gala Day with its procession was one of the most significant events in mining villages such as the Jewel and even in its damaged state this photograph is a valuable record of a vanished era. The bowlers are playing on the well kept green of the village Miners Welfare and Social Club, now the only visible remnant of its history.

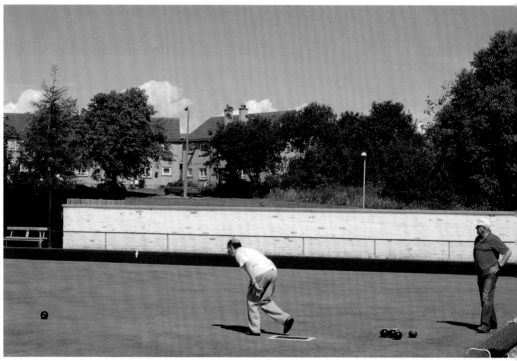

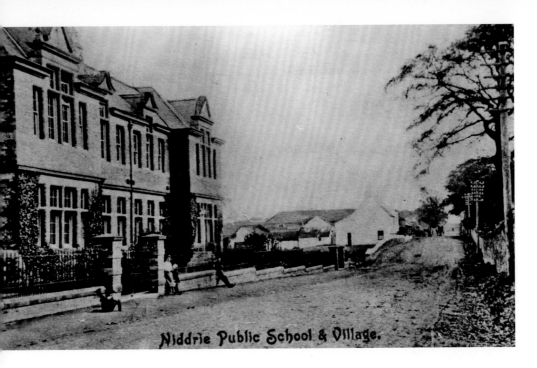

Niddrie Public School & Village.

Niddrie Mill School

The Victorian school is thought to have been the last building in the area built with Niddrie bricks. This is one reason that since it closed there has been a campaign to save it from demolition and put it to another use. Our photograph looking back along the main road towards the school, now hidden behind the trees, shows just how much the area has changed.

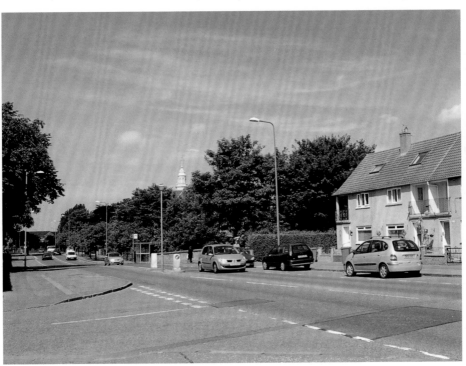

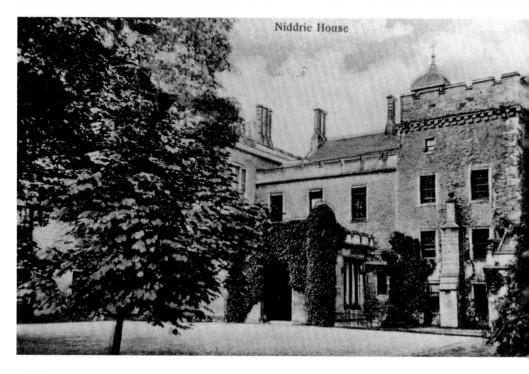

Niddrie House

Niddrie House
This mansion was the seat of the Wauchope family whose estate, including Craigmillar and much of its surrounding area, was bought for housing by Edinburgh Corporation in 1927. Not all of it was built on; this fine public park with playing fields and, seen here, the fully equipped Jack Kane Community Centre was created out of a large section of the estate at Niddrie.

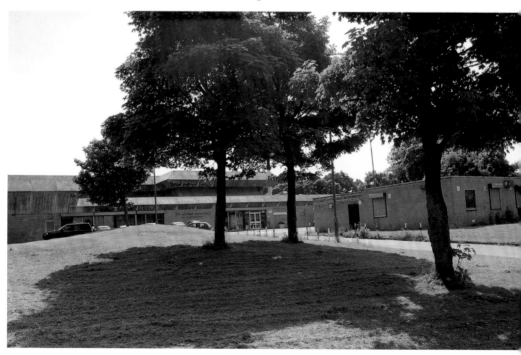

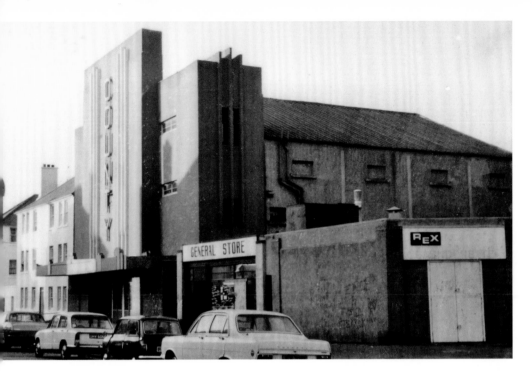

County Picture House

Meeting this local resident proved to be a lucky break when looking for the site of the County, which was in the former Wauchope Avenue. He used to live very close to the picture house and was able to point out the area on the grassy expanse where it and the Rex launderette once stood. Redevelopment of this area has stalled because of a lack of finance.

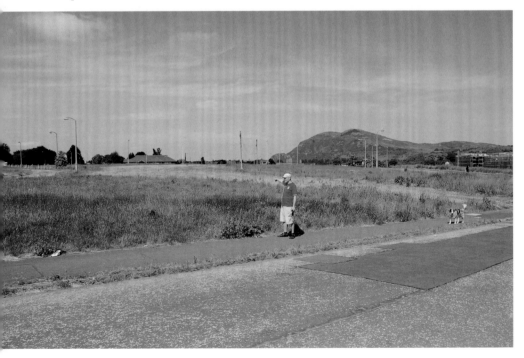

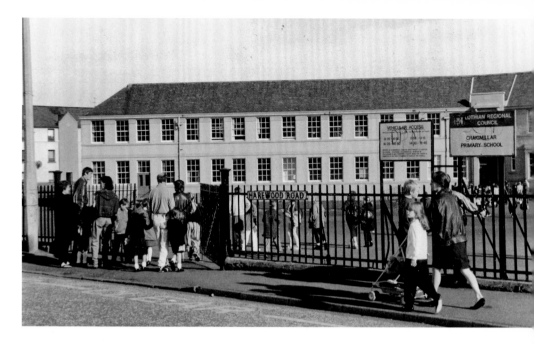

Craigmillar Primary School

This 1930s primary school escaped the wrecking ball because its assembly hall contains a mural painted by the distinguished Scottish artist John Maxwell. Now its rooms and facilities are used by a variety of community organisations. Artspace is the base from which Craigmillar Community Arts encourages the skills of local artists in a variety of media and exhibits their work in the John Maxwell Gallery.

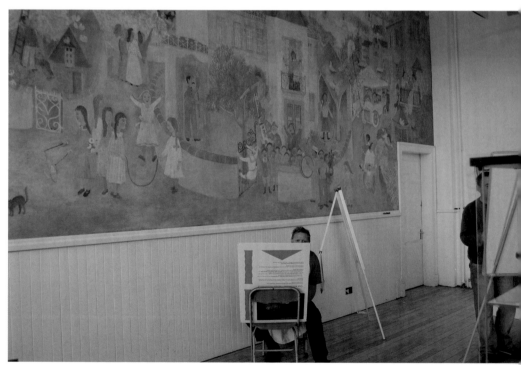

Doggy in the Window
The faithful dog guarding the garden tools may also have been a victim of the failure to redevelop the Wauchope area. In summer 2010 rebuilding has reached its very fringes but seems unlikely to proceed any further in the near future.

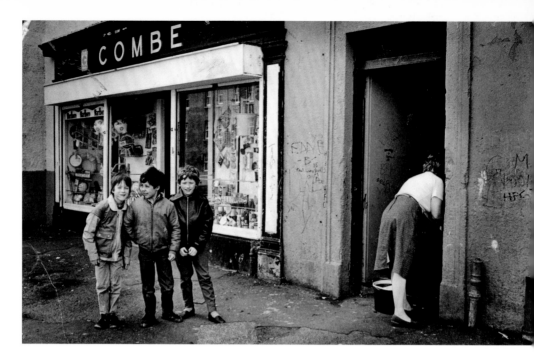

Local Shopping

Combe's general store in Niddrie Mains Drive was a victim of redevelopment but, unlike other communities, Craigmillar is still reasonably well served with small local shops. This is part of Niddrie Mains Road, Craigmillar's High Street so to speak, where local businesses are included in the regeneration that is taking place.

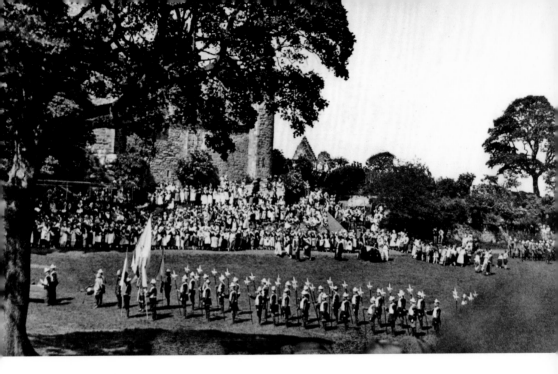

Craigmillar Castle

The fifteenth century castle commands a superb view over Craigmillar and the Lothians and was a favourite haunt of Mary Queen of Scots. In 1927 it served as a striking backdrop to a pageant organised by the Scottish aristocracy to celebrate Scotland's often turbulent history. Now in the care of Historic Scotland the castle presents an altogether more peaceful aspect.

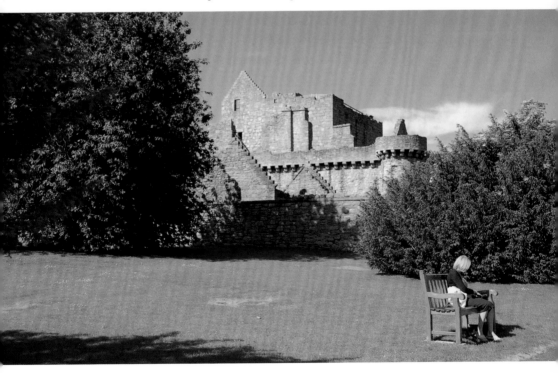

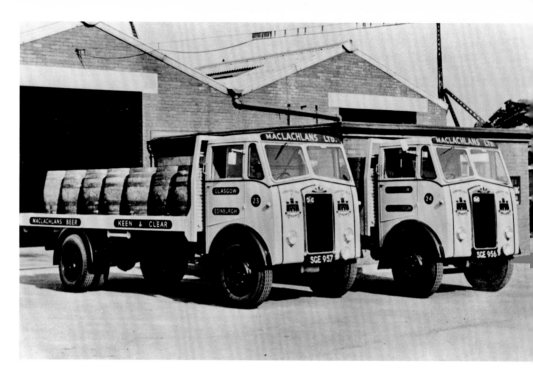

Holyrood Business Park

Most of the Craigmillar brewery sites were demolished when production of beer ended, but Younger's Holyrood Brewery has been given new life as a home for numerous small businesses. Here you can search for architectural salvage, have your garden redesigned or even arrange a personal fitness schedule.

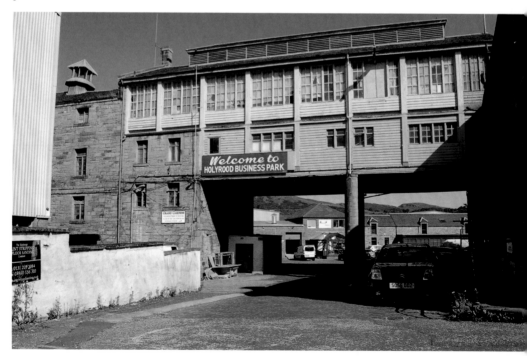

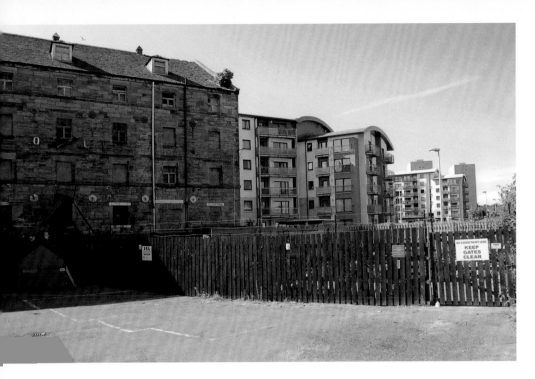

Aerial View

Our photograph was taken from the rear of the Holyrood Business Park looking over the former Dryborough Brewery site. In the distance are tower blocks from an earlier phase of council house building and it was from there that the shot showing the beginning of the demolition of the breweries was taken.

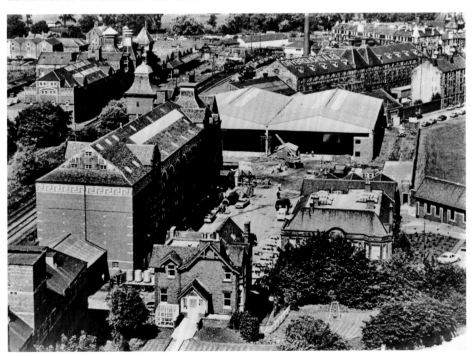

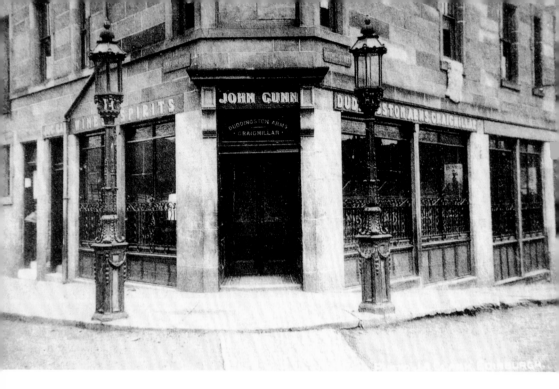

Local Watering Hole

This old-established, popular public house stands on the border of Craigmillar and Duddingston in the heart of the now vanished brewing industry. Unfortunately, an attempt at modernisation has seen the disappearance of the fine ornamental lamp standards and the installation of hugely inappropriate coloured window glass.

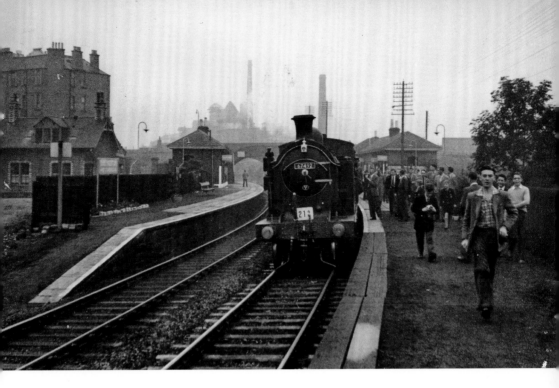

Duddingston Station

This is more correctly Duddingston and Craigmillar Station as it was built in 1884 to serve both communities, but its location some way south of Duddingston Village benefitted Craigmillar more. It closed in 1962 and nothing remains apart from the vestige of platform seen in the modern photograph.

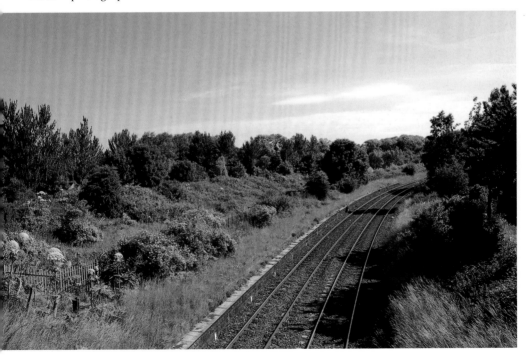

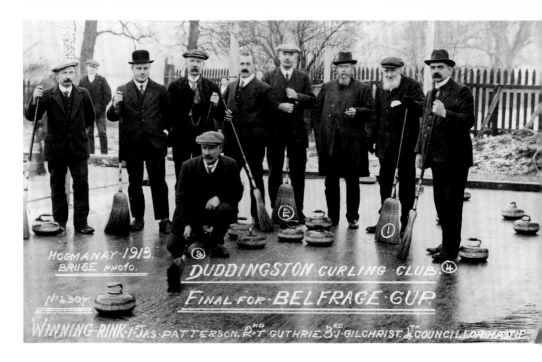

HOGMANAY · 1913.
BRUGE PHOTO.

Nᵒ 4907

DUDDINGSTON · CURLING · CLUB
FINAL · FOR · BELFRAGE · CUP

WINNING · RINK · 1ˢᵗ JAS · PATTERSON · 2ᴺᴰ · T · GUTHRIE · 3ᴿᴰ J · GILCHRIST · 4ᵀᴴ COUNCILLOR HASTIE

The Roaring Game

Curling is forever linked with Duddingston as the Duddingston Curling Society drew up the first set of rules to regulate the game in the nineteenth century. The 1913 curlers are not playing on the loch proper but on a large shallow artificial pond created on its south shore. The original octagonal curling house, now known as the Thomson Tower, has recently been restored and has a curling museum in its ground floor.

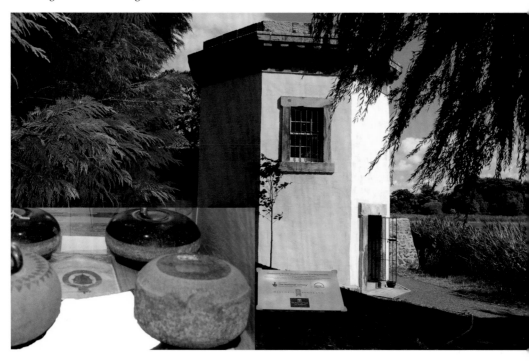

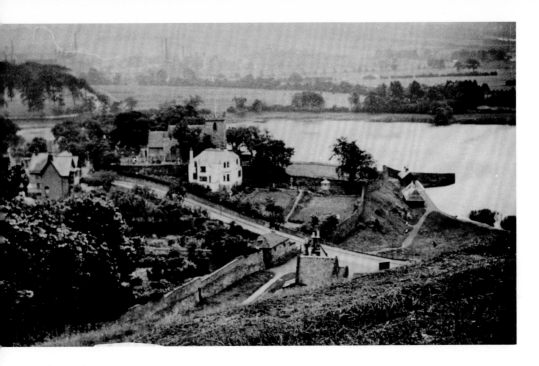

At the Park Gate

It is now almost impossible to see the Kirk and houses from this viewpoint because of the number and luxuriant growth of the surrounding trees. An indication of this is given by the photograph taken at the water's edge below the white house. The area by the little hut is a popular spot for children armed with fishing nets and jam jars, but quite a few are not keen to walk among the grazing geese.

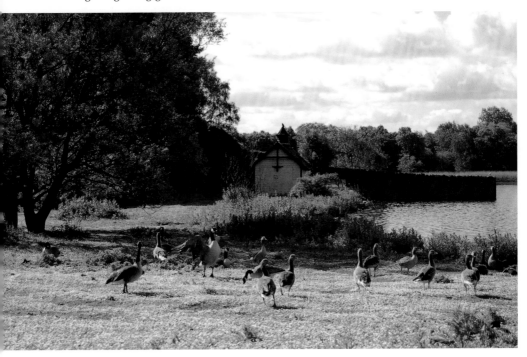

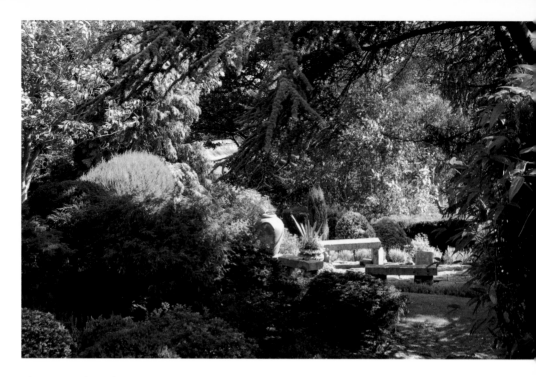

The Doctors' Garden

This green, peaceful sanctuary is part of the garden created by Doctors Andrew and Nancy Neil on ground between Duddingston Kirk and Manse and the loch. It was not only steeply sloping but bedrock lay just below the surface. Though helped by volunteers, the evolution of the garden was due largely to the dedication and hard work of the two doctors. The garden is now in the care of Dr Neil's Garden Trust, which was formed in 1997 to secure its future.

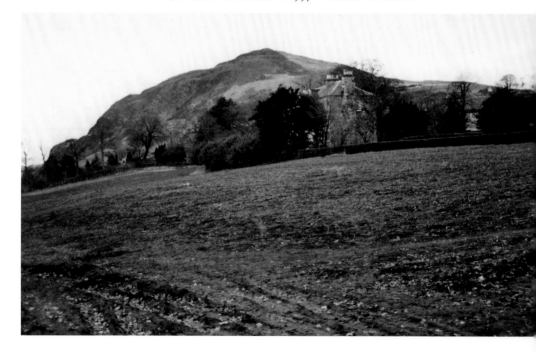

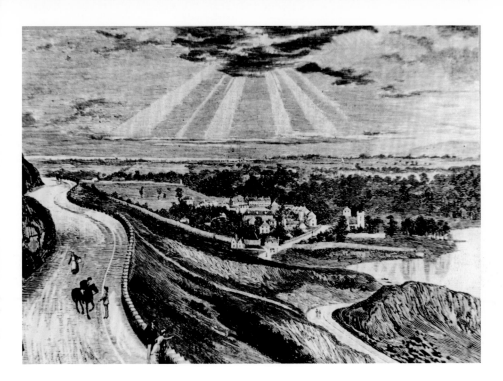

The Sheep Heid Inn

Local historians claim that there has been a hostelry to refresh travellers coming to Duddingston on the road round Arthur's Seat since the fourteenth century. The folk relaxing in the inn's beer garden could claim to be following royal precedent as Mary Queen of Scots was said to stop off here on her journeys between Holyroodhouse and Craigmillar Castle.

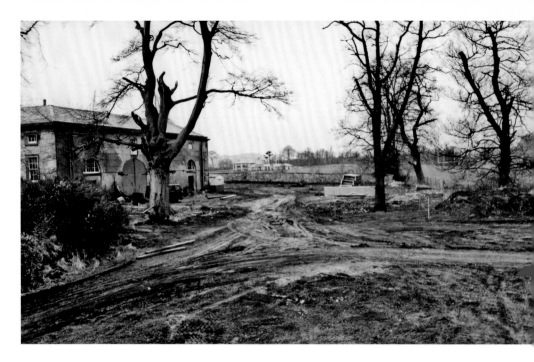

Duddingston House

Ground clearance and the building of access roads are underway beside the eighteenth century stable block of Duddingston House, the mansion completed in 1768 for the Earl of Abercorn. Latterly it had had a chequered career and was sold in its entirety to developers who, it must be said, have created an attractive, well-tended mixture of town houses and apartments. Our photograph was taken looking towards the Holy Rood High School playing fields with the stable building on our left.

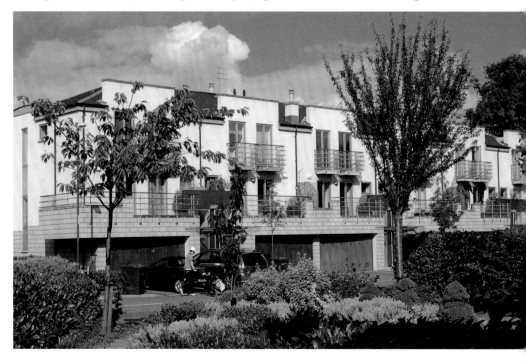

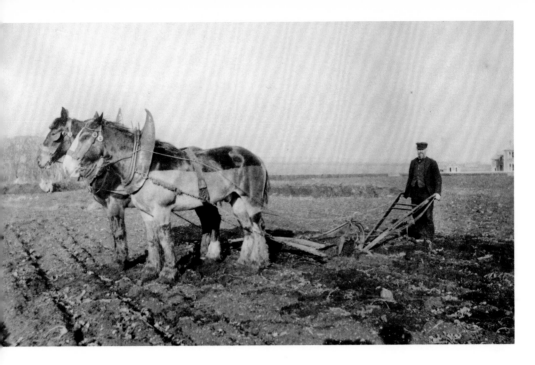

Southfield Farm

The ploughman is in one of the fields of Southfield Farm. All its fields, and those of Northfield and Meadowfield Farms, have been taken over by housing. Southfield Farm House, tucked away among modern houses off Duddingston Road, is the only farm building to remain.

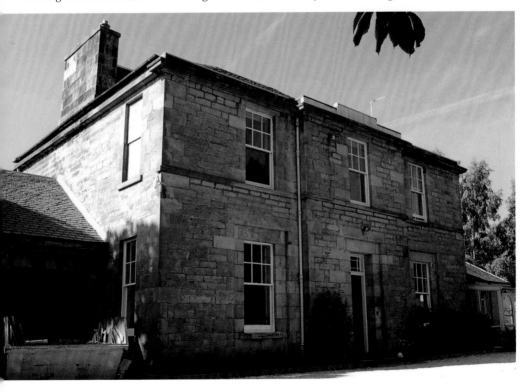

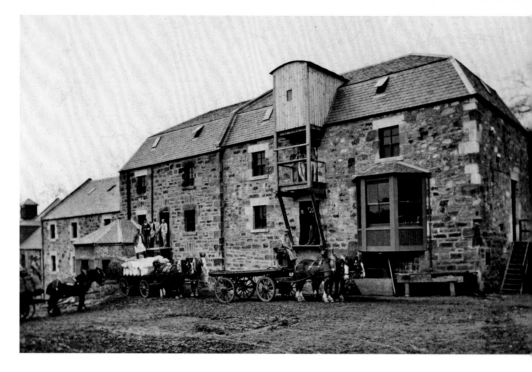

Duddingston Mill

Horse power is again in evidence in about 1915 to pull the laden carts from the granary. There had been a corn mill here beside the Figgate Burn for 600 years until it closed in 1950. The granary and other buildings were redeveloped and became an apartment complex.

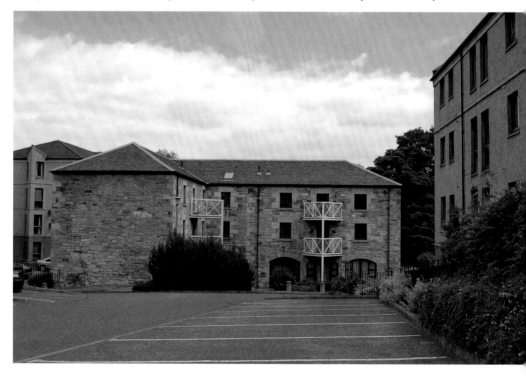

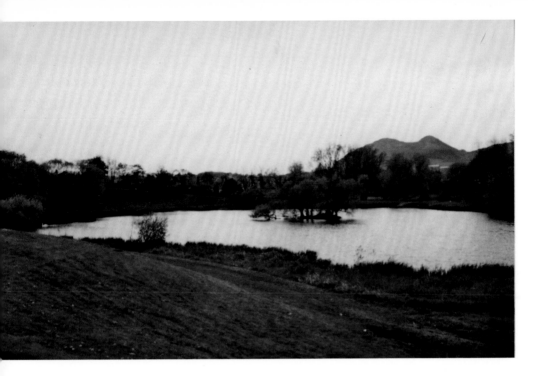

Figgate Park

The Figgate Pond and Park were created from a disused clay pit and an industrial site. A great deal of improvement work has been carried out in recent years and in 2010 the park achieved Green Flag status because of its innovative biodiversity plantings, and landscaping that included the building of a wooden walkway out over the pond.

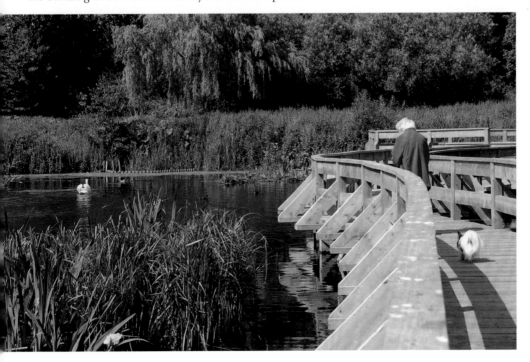

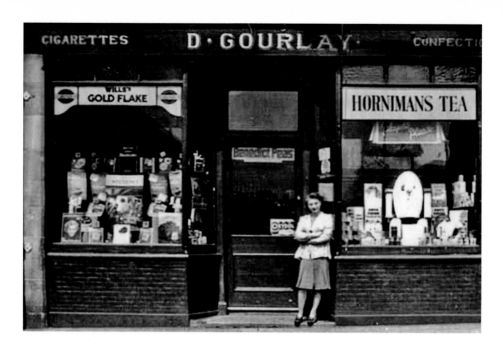

Piershill Terrace

Irene Raeburn was the Gourlays' young shop assistant and this was her first job on leaving school. She would doubtless be happy to know that the shop was still in business in 2010 despite the presence of a major supermarket directly across the street. It is still a newsagent and general grocer but also offers other services such as National Lottery and money transfers.

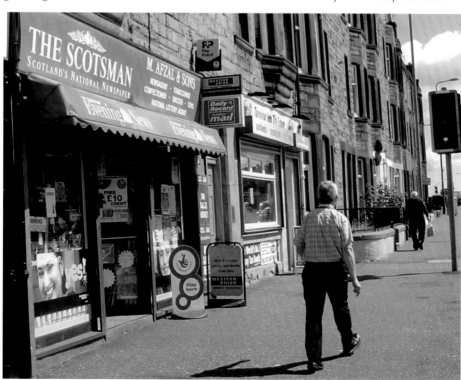

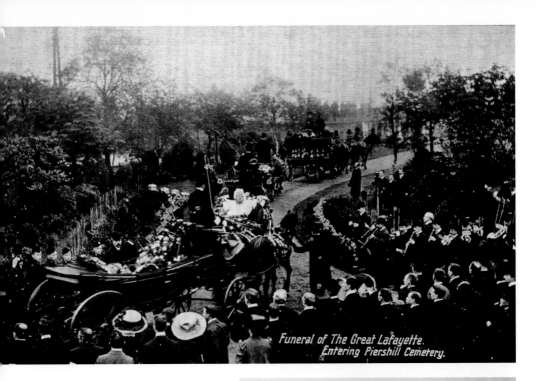

Funeral of The Great Lafayette.
Entering Piershill Cemetery.

Piershill Cemetery

The interment of the American illusionist The Great Lafayette and his dog, Beauty, on 14 May 1911 is probably still the most spectacular event in the cemetery's history. After falling into a dilapidated condition, and in danger of falling down, his marble memorial was restored to its former splendour in 1992 thanks to the efforts of members of the Magic Circle and the cemetery owners.

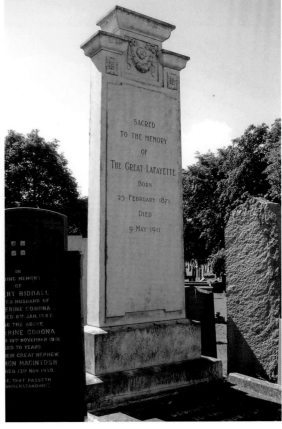

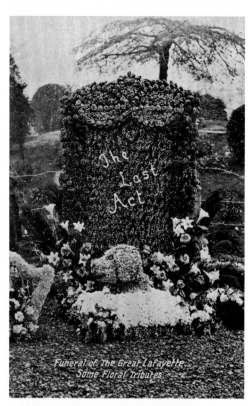

Funeral of the Great Lafayette.
Some Floral Tributes

Beauty and other Pets

Lafayette died in a fire that destroyed the stage of the Empire Palace Theatre (now the Festival Theatre) in Edinburgh on 9 May 1911. He was buried in Piershill as it was the only cemetery that would agree to bury him beside his dog, Beauty, who had died four days earlier. Piershill Cemetery has an area set aside in which owners can erect memorials to pets that have died and walking amongst them is quite a touching experience.

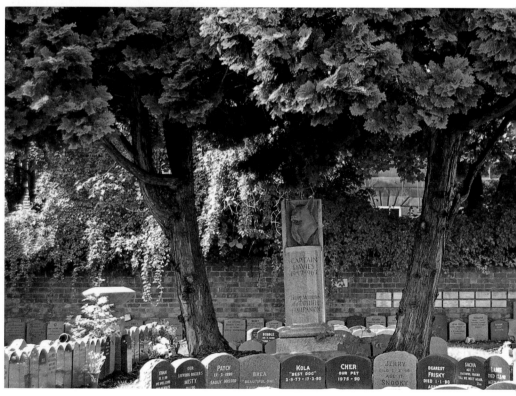

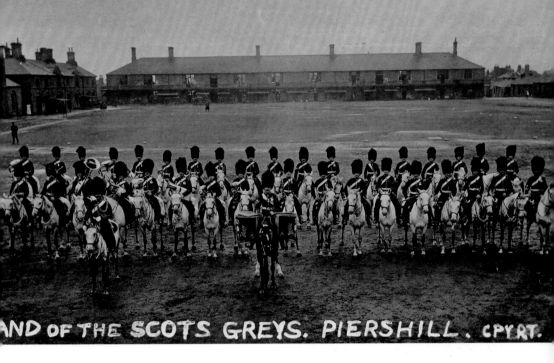

ND OF THE **SCOTS GREYS. PIERSHILL.** CPYRT.

Piershill Barracks

These very large barracks were on Portobello Road and date from the late eighteenth century. The cavalry regiments billeted there used to exercise their horses on Portobello beach. When Edinburgh Corporation built houses on the site it reflected their origins by continuing the basic layout with houses round three sides of two open squares.

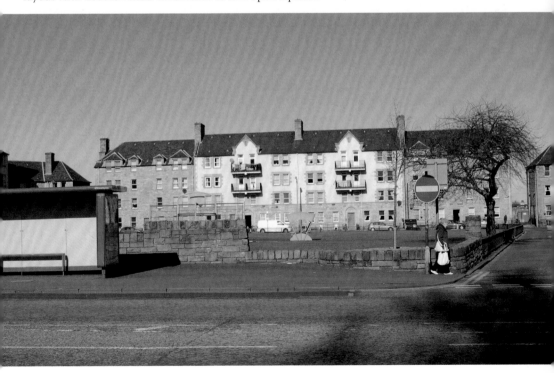

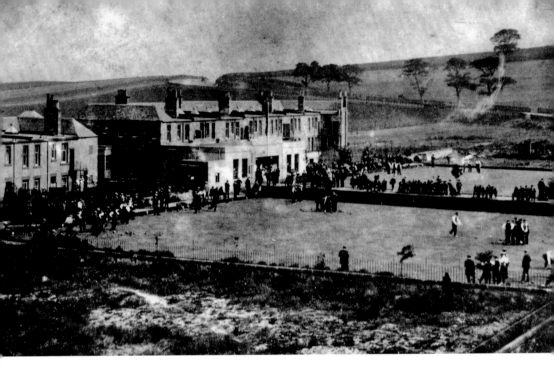

Willowbrae Bowling Club
The club was founded in 1910 and unusually for that time had male and female members on an equal basis from the beginning. The clubhouse has been enlarged but not much else has altered on the greens between 1914 and 2010. However, Willowbrae Road and beyond is now totally hidden by house building.

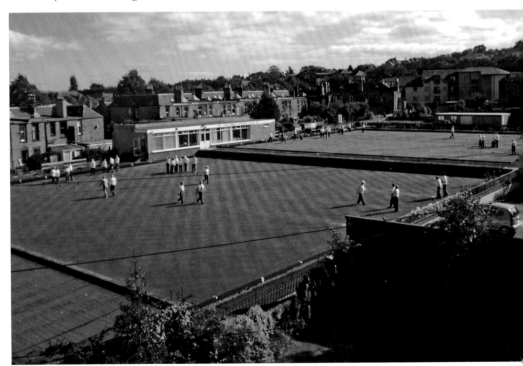

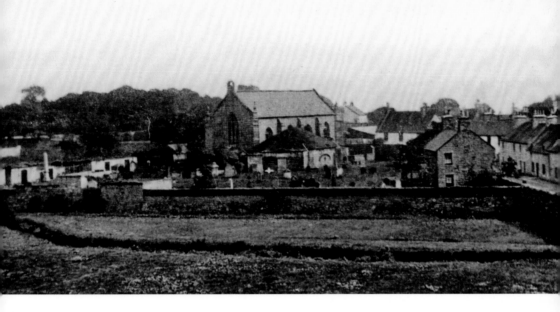

Restalrig Church

Restalrig kept its village character until Edinburgh Corporation started building housing around it in the mid-1920s. The church has always been at the centre of the village and although the present building dates from 1836 it stands on the site of one built in 1487. Apart from the fifteeenth century St. Triduana's Well next to the church the churchyard has some interesting memorials but the tower belongs to the Fire Station over the boundary wall.

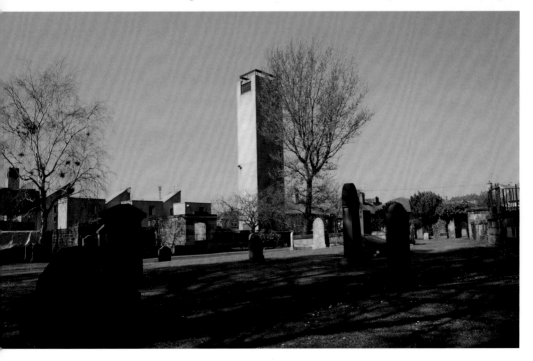

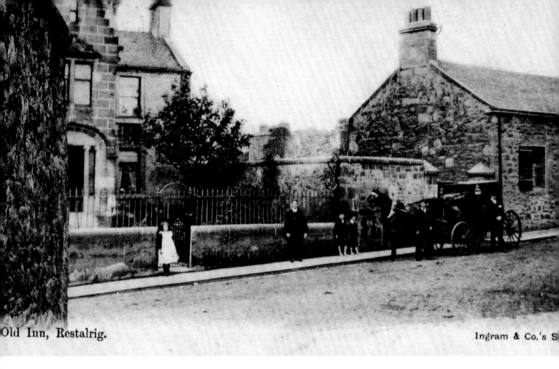

Old Inn, Restalrig.

Ingram & Co.'s S

Brooklyn House

Not a great deal has changed here except that the Old Inn has been converted to a dwelling house and a motor car has replaced a horse and cart as transport. The two storey house has always been known as Brooklyn, allegedly because it was built by someone who had become wealthy through trade in America.

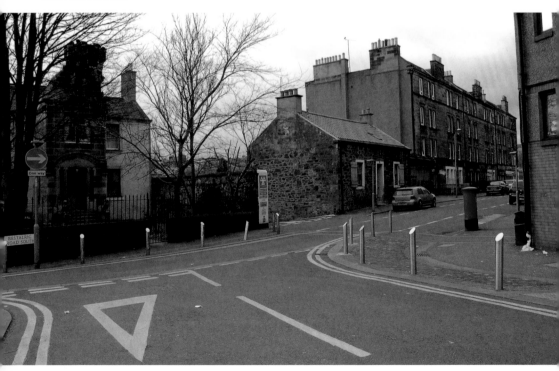

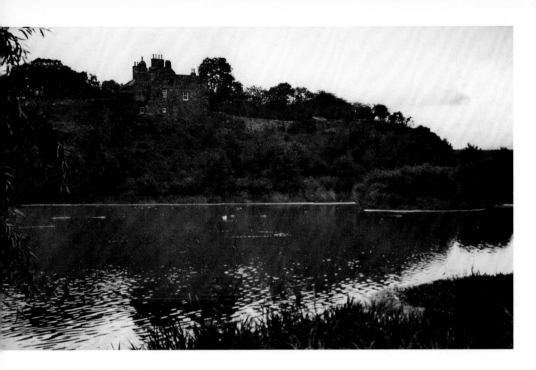

Lochend Castle and House

In black and white Lochend Castle on the hill above the loch looks quite forbidding but appearances can be deceptive. The ancient castle was almost completely destroyed in the seventeenth century and lay ruinous until its gable was incorporated into a large mansion built around 1820 and called Lochend House. The house chimneys are just visible behind the old building and the union can be seen in the photograph taken at the rear of the house.

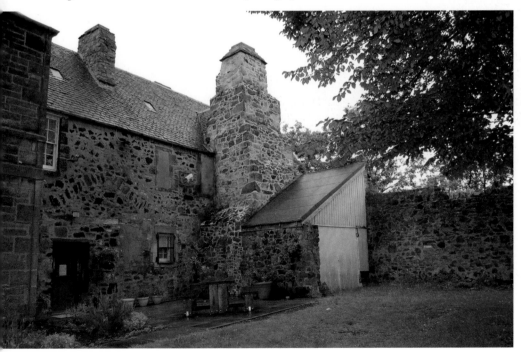

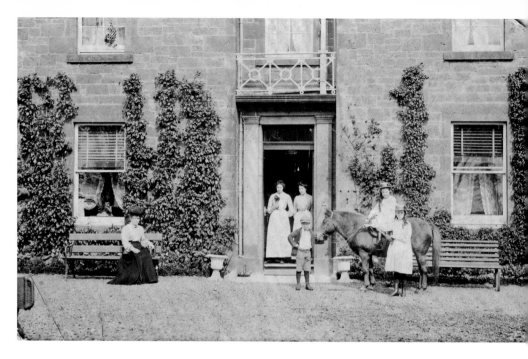

Craigentinny Estate

This house, now known as South Bank House, still stands in Portobello Road. In 1910, as Craigentinny Farm, it was the home of Andrew Bryce and his family. He farmed 400 acres and was Steward for the entire Craigentinny Estate farm lands. Apart from the municipal Craigentinny Golf Course all these lands have been covered by housing.

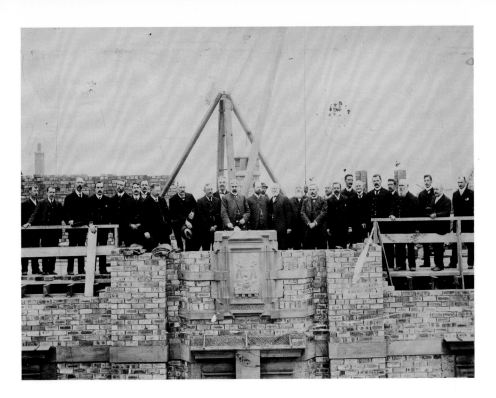

Continuing Care and Support

This group of dignitaries are attending the laying of the memorial stone of the new South Leith Poor House at Seafield in 1906. Leith's coat of arms and motto, Persevere, can clearly be seen. This eventually became the Eastern General Hospital but now the gatehouse is its only remaining building. It now forms part of a new community care facility.

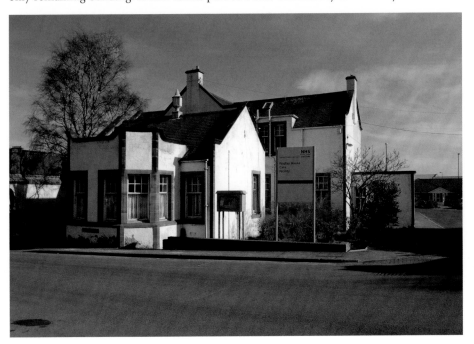

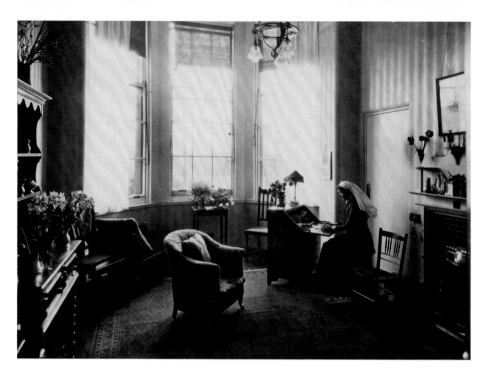

Changing Technology

The buildings were used as a military hospital during the First World War. Miss Kinloch, the Matron, conveys an atmosphere of calmness and control in her beautiful, bay-windowed room. Compare this with the security cameras and modern technology of the new reception for Findlay House.

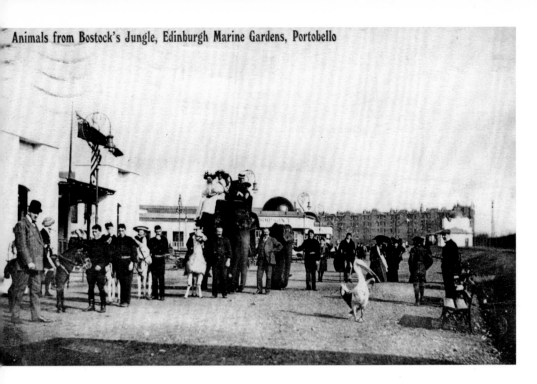

Animals from Bostock's Jungle, Edinburgh Marine Gardens, Portobello

Animals on Parade

The full name of the pleasure garden that opened in 1909, on 27 acres of ground west of King's Road, was the Edinburgh Marine Gardens and Zoological Park. The animal parade, in which the pelican seems to be the star performer, was a popular attraction on the roadway outside the Gardens. In the same location today one has to be content to look at cars or visit DIY showrooms.

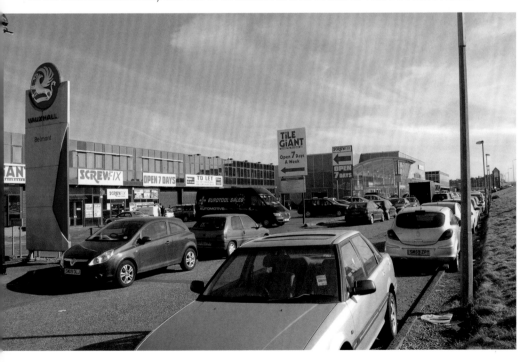

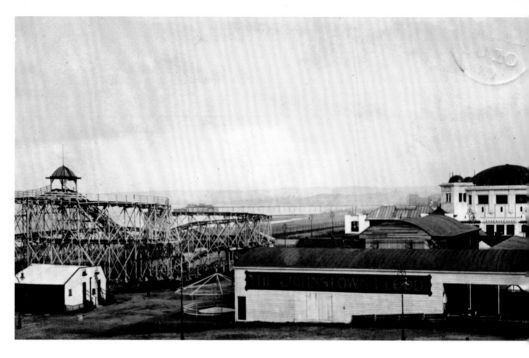

Hover Crossing

There are plans for an exciting new facility on land beyond where the Marine Picture House, the Figure Eight Railway and the Concert Pavilion once stood. It is proposed to build a terminal for a hovercraft ferry to link Portobello and Kirkcaldy in Fife. Successful trials were held in 2007, which was when this photograph was taken.

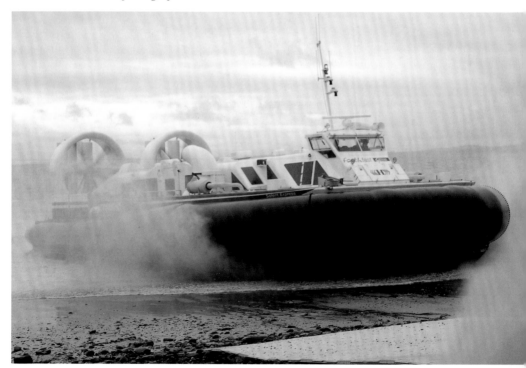